POSTCARDS OF THE NIGHT: VIEWS OF AMERICAN CITIES

Museum of New Mexico Press
Santa Fe

in association with
the Center for American Places

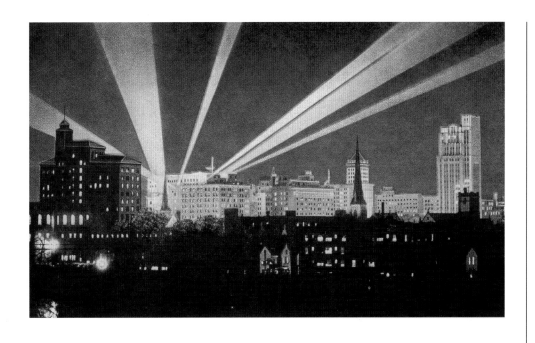

POSTCARDS OF THE NIGHT: VIEWS OF AMERICAN CITIES

John A. Jakle

· For Cindy ·

Cover image: San Francisco, California, 1960s, taken from the elevator of the Fairmont Hotel.

This book was developed by the Center for American Places (P. O. Box 23225, Santa Fe, NM 87502, *www.americanplaces.org*) in collaboration with the Museum of New Mexico Press.

Project editor: Mary Wachs
Art director: David Skolkin
Composition: Set in Bembo
Manufactured in China
10 9 8 7 6 5 4 3 2 1

Library of Congress Cataloging-in-Publication Data

Jakle, John A.
 Postcards of the night : views of American cities / John A. Jakle.
 p. cm.
 ISBN 0-89013-456-1 (cloth : alk. paper)
 1. City and town life—United States—Pictorial works. 2. United States—Social life and customs—1918–1945—Pictorial works. 3. United States—Social life and customs—1865–1918—Pictorial works. 4. Cities and towns—United States—Pictorial works. 5. United States—History, Local—Pictorial works. 6. Night photography—United States. 7. Postcards—United States. I. Center for American Places. II. Title.
 E169.J25 2003
 973'.09732'022—dc21
 003006558

Museum of New Mexico Press
Post Office Box 2087
Santa Fe, New Mexico 87504

CONTENTS

*M*Y INTERESTS IN THE AMERICAN NIGHT, and its depiction in postcards, were come by honestly. As a ten year old, there was that January train trip across a nighttime Kansas, the darkness punctuated by a line of revolving beacons, intermittent flashes of light visible just beyond the horizon in a line parallel to the train's path. What a profound sense of emptiness and isolation! Then there was that August night a few years later at the roof garden of the Astor Hotel in New York City. Unwilling to "swing and sway with Sammy Kaye" (and his orchestra) and determined to allow my parents a pleasant evening, I wandered alone out along the rooftop railing to see the lights of Times Square. C-H-E-V-R-O-L-E-T was spelled out over and over again directly at eye level. As I leaned out over Broadway, cars and trucks below streamed convulsively as traffic lights sequenced from red to green. A face on a large billboard blew gray smoke rings that shimmered blue in the night light. It sure wasn't Kansas anymore! I felt myself not only at the heart of a great metropolis but at the heart of America, and maybe even at the center of the world. I remember being overwhelmed by a profound sense of adolescent self-importance.

Like many kids growing up, I had relatives who, when vacationing, sent me postcards as they traveled from place to place. One spring, an aunt sent a cascade of postcards from Florida depicting orange groves, pelicans, palm trees and beaches, and very nearly everything else the state had to offer. Her's was a herculean effort. By the time the tenth or eleventh card arrived, I had become a dedicated postcard collector. They were the bright, colorful linen postcards that depicted places not only through the lens of a camera but through the pen of a photo retoucher.

Scenes were cleaned up to appear at their very best. I am not sure that I realized this then. Certainly, I did not mind that "reality" was somewhat distorted. I just saw the cards not only as pleasing but as invitations to someday go and see the places depicted for myself.

Like most childhood enthusiasms, my collecting of postcards lasted only a few years. An old shoebox in my parents' attic entombed the treasure until, many years later after finishing graduate school and poised to launch myself as an assistant professor of geography, I discovered the cache with its postcard trophies very much intact. I recall the instant realization that those images had value, that they could be used in the classroom in teaching about past landscapes. They were instructive as to what places once had been. More importantly, they were instructive as to how places in the past had been represented. They instructed as to how America had been pictured.

Today, I approach the end of a college teaching career at the University of Illinois at Urbana-Champaign. My courses have been very much focused on the history of America's diverse built environments, primarily attracting students from landscape architecture, urban and regional planning, and architecture and architectural history. I have pursued diverse interests across the boundaries of historical, cultural, and urban geography but always in interdisciplinary frame. I have published a dozen books on a range of topics, yet in almost every book, and in many of the dozens of scholarly articles I've published as well, postcard images have figured. I fully realize that many of my later-in-life interests actually were excited when I was quite young, and I have taken delight in revisiting many youthful preoccupations as an adult and a scholar.

I consider myself to be a "landscape historian" more than anything else. As such, I have emphasized in my work the commonplace of recent history: specifically, the vernacular of the twentieth century with a focus on America's changing landscape. I was born just before World War II. Until a teenager, I lived, one might say, in the 1920s atrophied. The Great Depression of the 1930s and World War II and its aftermath of the late 1940s fossilized much of the nation's cultural landscape. Decades-old ways of doing things prevailed in many kinds of places. As a child, I thought that small grocery stores, where clerks waited on customers from behind counters, would be around forever. Main street or downtown was where one shopped and where one always would shop in the future. I remember lots of things that have since changed, indeed that have changed dramatically, most with clear automobile implication. Over the past decade, much of my scholarship has focused on the role of the automobile in reorganizing America's twentieth-century geography. Nothing has impacted America's landscapes more than auto use.

What a challenge to the historian! How is the scholar to make sense of it? My way has been to focus on landscape, specifically on the ways in which places (defined at various scales) have nested within landscape as built environment. The study of places through their depiction has proven most intriguing. Photographs of past landscapes especially have enabled me to more readily establish degrees of "base level" comprehension: understandings from which to assess change over time. To that end, no form of visual imagery has proven more useful to understanding the nation's past geography, and what people thought of that geography, than the picture postcard.

Herein I offer an examination of early-twentieth-century postcard art, specifically American urban nighttime views.

How was the American city after dark depicted in post-cards? What were the topical emphases? What compositional formulas were favored? What did those orientations pretend socially? These are the questions asked in this book, an exploration of the postcard as a significant contributor to American popular culture.

Through much of America's history the dark of night was something to be avoided. One stayed close to hearth and home since danger lurked in the darkness, from the very real evils of society's criminal classes to the unreal fears of the supernatural. It was in cities, through the artificial illumination of public spaces, that night was made into something very different. Rather than a time for shunning, the night became a time of positive anticipation if not of outright celebration. Public surveillance, possible in the day, was extended into nighttime hours, with bright light rather than dark shadow made to characterize urban places. Streetlights, floodlit landmarks, towering buildings with windows all aglow, flashing electric signs, searchlight beams crisscrossing in night skies: all of these spoke of a new modern era with society's progressive elements fully in control.

Bright night light invited artistic response. Numerous were the journalists, novelists, painters, and photographers, among others, who experimented with nighttime depiction. If Americans early in the twentieth century could not witness firsthand (or witness firsthand frequently) the array of new nighttime attractions, then they could do so vicariously through the consumption of art. Especially could they do so through the instrument of the lowly postcard. By 1910, postcards had come to substantially influence America's vision of landscape and place.

Whether sent by travelers to friends and relatives, used in everyday correspondence, or simply collected, the post-card was a principal means by which urban scenes were known. The postcard view of a city street or a landmark building could be readily possessed as a thing held in the hand. It enabled the viewer to "own" a scene seemingly frozen in time. In addition, postcards were cheap, and almost every American could afford to buy and use them in large quantities. To the extent they were art in this regard they were unlike most other art forms.

Sending and collecting postcards quickly reached a level of fevered enthusiasm. By the hundreds of millions annually, postcards passed through the nation's post offices, with scenic cards the most popular of all. Postcard publishers created card sets that depicted for virtually every locality the principal sites (or sights) by which it might be known and remembered. For cities, depicting the new nighttime look was important even though the predominant photographic and printing technologies for doing so remained primitive through the threshold of World War II. Representational quality aside, the night simply could not be ignored. With increased affluence and leisure time, the nighttime city had grown in economic and social importance. Night was increasingly the time of recreation, with brightly illuminated entertainment venues beckoning the consumer's dollar. The new tourist city was substantially a nighttime place for which the souvenir postcard needed forcefully to speak.

For Americans today, old postcard views hold special appeal. Like all historical photography, postcard views offer an invitation to step into a scene captured in the past, perhaps the closest thing that we will likely ever have to "time travel." My purpose in writing this book is to encourage readers to step inside the frames of these historical views and have a good look around. How is each scene, as visual display, constructed? What were early viewers invited to

comprehend, and what do today's viewers see? I seek to identify the visual iconography by which early-twentieth-century American cities at night were known. What values were postcard images of the urban night intended to sustain, and to whom, and for whom, did nighttime postcard scenes speak? This study offers no mere invitation to visual nostalgia but an opportunity to comprehend past social reality.

Postcards of the Night is organized as follows. In an introductory essay, I set historical context by outlining the rise of an urban America and the role that postcards played in its depiction. Postcard photography is treated in relation to photography in general, with an emphasis on how darkroom and printing techniques were used to produce nighttime visual effects. Nighttime postcard views are explored as a form of "visual culture" as well as a material form of "popular culture." There follows a "gallery" of eighty-two postcard views: a sampling of nighttime scenes from selected American cities arrayed in alphabetical order from Albuquerque through Youngstown. The bulk of the views are from the first four decades of the twentieth century although a few, by way of offering contrast, date from as late as 1975. Each view is accompanied by a caption to direct the reader's attention to one or another aspect of a scene pictured. Taken together, the captions outline how urban postcard views of the night were structured and what they might have meant to postcard viewers in the past. An appendix offers a guide to collecting postcards.

Scholars and lay readers interested in the history of the urban built environment and its picturing in the visual arts should find much of interest. So also will postcard aficionados as well as dedicated deltiologists. The postcard has served as an important means by which Americans in the past visualized their cities day and night. To focus on night images, however, is to elicit a special appreciation of the postcard and its role as an art form. What the postcard was, and what it pretended to represent of America's cities at night, is the story told here.

*W*AS THERE EVER ANOTHER TIME OR PLACE where change enveloped so many people so quickly and dramatically as in the early-twentieth-century United States? The electrification of America, Thomas A. Edison's promise of the century before, was substantially realized early in the 1900s, setting off a revolution in transportation and communication. The child who came of age in an era of kerosene lamps and horse-and-buggy roads reached his middle years amid the rapid innovations of the automobile, airplane, radio, and motion pictures. In cities and towns all across the country, illuminated nighttime was exploited for work and leisure.

Emergent technology both reflected and drove fundamental economic, political, and social change. The giant corporation matured as supplier of capital, instrument of labor management, exploiter of natural resources, manufacturer of industrial product, and marketer of goods and services. Local, regional, and national orientations gave way to a global outlook. Success in war thrust the United States into world political leadership, a position of power sustained by the nation's agricultural and industrial strength. Attracted from overseas was a flood of immigrants who, joined by a like tide of rural Americans displaced by agriculture's mechanization, swelled America's cities as never before. The United States became an urban nation, its rural roots substantially diminished demographically with each passing decade. Socially, the nation found itself stratified in new ways, a much enlarged, better educated, and upwardly mobile middle class coming to typify American life.

American culture changed. The fads and fashions of society's elite exerted less and less influence in the face of

emergent popular enthusiasms, especially as Americans found new ways to spend increased leisure time. Reduced workweeks and shorter working days, combined with rising incomes, encouraged new forms of consumption with clear recreational implications. Visual spectacle came increasingly to the fore: spectating at sporting events, witnessing festive celebrations, seeing exhibitions (including the many world's fairs), viewing motion pictures (the growing favored form of theater), consuming still photographs in advertising and in the print media generally, and traveling to see places firsthand as tourists. Visual images flooded everyday attention. Seeing increasingly came to be equated with experiencing.

The postcard's significance loomed large. Scenes depicting landscape and place dominated postcard publishing, making postcards one of the most popular means by which images of the built environment circulated among ordinary Americans in the years up to World War II. Postcards, whether collected by tourists as souvenirs or mailed by them to relatives and friends or merely sent by locals in everyday correspondence, instructed as to how places looked and as to how places might be looked at. Regarding the night, what were cities like? How might they best be seen after dark? What did the nighttime city mean? Postcard art distilled the nighttime city into a mosaic of fragmented images. These images, repeatedly consumed over time, set a template not only for knowing specific cities after dark but also for knowing cities in general at night. Postcards offered vicarious experience while also inviting direct experience by setting expectations for actual firsthand knowing.

The darkness of night partially obscured whereas the brightness of day more fully disclosed. Things illuminated artificially attracted and held the eye's attention. Visually, a nighttime scene was but a semblance of its daytime equivalent, often with very different attention-getting emphases. Nighttime landscapes appeared substantially edited or simplified, their visualizations reduced to elemental outlines. Photographs of nighttime landscapes, like those used in postcard views, offered further editing. Photographers in composing pictures included and excluded, disclosing to viewers only a limited spectrum of what could be seen. In depicting the night, postcard publishers relied on but a narrow range of pictorial orientations, what might be called visual "fixes." Inherent was the photographer's choice of viewpoint and the specific visual devices used to compose pictures as vistas, as well as darkroom retouching techniques. Inherent, too, was the printer's skill at halftone and other processes of photo duplication.

Photographs became an important means of communicating. Today, photographic images dominate our knowing about the world, especially the world at a distance. Our reliance on visual representation has been greatly amplified by television, interactive computers, and other electronic devices that vastly expand the representational powers of still photos. Central to this is the sense of realism that such visual imagery conveys as iconography. Photography suggests truthfulness in what it portrays. The traditional photograph is the product of a chemical/mechanical process presumed capable of rendering "virtual" visual records. Thus, the photographer easily is denigrated as the mere facilitator, a partial manager of what belongs essentially to "reality" beyond the camera lens. Often the viewer of a photograph does not "see" the photo itself as an art form but only what is represented of the recorded world within.

Photographers, by rendering images in exacting detail,

seemingly accomplished what other artists could not. The realist painter stood suspect of overly editing reality, of picturing selectively. The photographer was not immune from such a charge, but the presumed neutrality of the camera—as objective instrument—suggested truthfulness. Writers who sought realistic depiction with words clearly stood as subjective in their art. Word pictures played with the reader's memory; different readers were led to imagine different things based on dissimilar past experiences. Yet photographs were, and are, very much the same. Meanings assigned by viewers necessarily derive from their previous experiencing of things depicted and, indeed, reflect also past experience with using photos. Pictures often are combined with words. Postcards, for example, usually carry written captions descriptive of the scenes pictured. It can be argued that for a visual image to hold consistent meaning viewer to viewer, it must be interpreted in words (Crary 9).

The souvenir postcard emerged as a form of realist art following from traditions previously elaborated on in literature, painting, and, of course, art photography. Postcards did not constitute high art; rather, they were intended for mass consumption, a vernacular product largely of the commercial market. The view card was a means of commodifying place: offered was a cheap and easily handled pictorial facsimile of a landscape or a place ready for visual consumption. Postcard representations were readily accessible to every spectrum of American society. They could be collected as a novelty, but, more importantly, they could be sent to others as a means of communication engendering social connection. A postcard view sent messages about both its sender and its recipient. Implicit was a kind of shared experience: "This is what it's like." "You can see this here." "Someday you will have to come and see for yourself." Such thoughts often invaded forcefully when pictures were combined with captions and, as well, with personalized written messages. Attention was either directed into or toward the photo or, conversely, away from it. Nonetheless, the excuse for communication was the "view" with its geographical implications for knowing the world as collective reality.

SPECTATORSHIP AND THE GAZE

The postcard, with its faddish reception as purveyor of place imagery, did not spring from whole cloth. Rather, it followed in the tradition of the "flaneur" (the observing walker in the city), the novelist (many of whom assumed the flaneur's stance), the realist landscape painter, and, of course, the landscape photographer (Benjamin 36). A kind of nineteenth-century tourist for whom the gaze was all important, the flaneur strolled through the city observing its spectacles, a would-be connoisseur of human nature. The flaneur was a seeker and an interpreter of visual images: the consumer of a ceaseless succession of illusory, commoditylike visual impressions. He walked at will, seemingly without purpose but always inquisitive, wondering about what he saw and often focusing, as many feminist writers emphasize, on members of the opposite sex. The flaneuse, for her part, arrived with the shopping arcades and department stores that provided security. There women looked not at men so much as at other women—how they dressed and how they behaved—and, of course, at the merchandise displayed not only to be seen but to be bought. The flaneuse tended to be a shopper, a gazer through shop windows.

Scenic postcards appropriated the gaze, directing it toward landscape as the physical container of social life. They abstracted from built environment the sense of spec-

tacle, encouraging the viewer of postcards to become a spectator. One could play vicariously the role of the flaneur (and, indeed, the role of the flaneuse) through that depicted by the lens of the camera. The focus was not other persons, although people usually could be seen in the scenes depicted, or on the commodities displayed, although store windows often could be seen when shopping streets were pictured. Rather, it was the city itself that was made into a kind of fetish. The postcard commodified the city as visual display.

Scenic postcards saturated Americans with visual imagery. In the emerging modern society, people and their places came to be referenced in stereotype, often visually. Through impersonal stereotyping, people in modern society were separated from many of the highly personalized connections that previously had forged community. Increasingly, people came to be known for the places that they frequented and those places, in turn, for how they looked. How places looked in postcards was a function of prevalent ideologies, for example the boosterism of business elites interested in depicting cities as progressive and modern. An urban view, as a salable commodity, was expected to flatter a city, in the process reinforcing prevailing economic, political, and social agendas. Postcard views were expected to celebrate cities and do so in ways that would preserve, if not strengthen, the social status quo. As a result, only certain kinds of places tended to be pictured and only in certain ways.

NIGHT LIGHTS AND CITY SCENES

The American city was many things, but real estate speculation and land development were always in the forefront. The nation's cities evolved primarily as business propositions, developmental strategies driven forward through shifting coalitions of power players: bankers, industrialists, merchants, politicians, government bureaucrats, and, of course, the controllers of the media, the latter shouldering the responsibility for publicizing—even propagandizing—on behalf of initiatives favored. Postcard images of the city, including those of the night, were made to appear inevitable to the masses, the powers of city formation usually cloaked from view in the process. Central was the sense of spectacle. Spectacles—everything from the staged events of festivals and exhibitions to shopping arcades and department stores—excited a collective sense of community belonging, of individuals being a part of an evolving city. Modern lighting in particular brought a sense of spectacle to the city space at night. Indeed, little was more exciting to the eye than a new lighting scheme, especially when first introduced at a large scale across public space. Postcard publishers met the challenge of depicting the implicit modernity, with the spectacle of the illuminated night becoming a fundamental part of America's symbolic economy.

The commercial postcard celebrated modernism through the depiction of monumental buildings, bustling streets, and all manner of engineering accomplishment and scientific innovation. Implicit was a sense of progress—that America was fully "up to date"—emphasized were evidences of modern creativity to which all Americans could look in admiration if not in awe. It has been argued that the illuminated nighttime way was thought of as "technologically sublime" (Nye 1996, 173–98). Pictures of the new urban night reflected positively not only on technology but on new forms of social organization, particularly big corporations and big government—the institutions that made nighttime illumination possible.

Today, many distinctions between night and day are blurred through artificial illumination. The geography of night now replicates the geography of day in numerous ways as places of work and leisure are made to function continuously across the diurnal cycle. Certainly, time is homogenized by the likes of the night shift, the twenty-four-hour supermarket, and the open-all-night diner. Streetlights blaze in excessive brilliance, converting night into a semblance of day. Illuminated signs sell their wares silhouetted against a much diminished darkness. Floodlit facades, lighted display windows, flashing beacon lights, rotating searchlights, choreographed traffic signals, skylines outlined by constellations of lit windows: all of these things are fully accepted as a part of contemporary American life. Thus, nighttime lighting has become so inherently facilitating that today we tend to accept its benefits all too readily while too infrequently stopping to marvel at its delights.

Of course, this was not always so. Americans did not always take the illuminated night as given. In the past, Americans marveled as artificial lighting innovations were demonstrated and adopted to a variety of uses. Oil, gas, and then electrical illuminations came to the fore in defining new nighttime possibilities, especially in cities. Americans embraced the new landscapes of night with varying degrees of excitement although they declared the illuminators, such as Thomas Edison, to be folk heroes. Photographers and other artists experimented in their respective mediums to record and assess the visual impact of the new phenomena. At first, lighting converted the ordinary into the extraordinary as new kinds of places were invented for nighttime use and as daytime places were extended into the night, often with changed social function and meaning. The night was "colonized" as the frontier of darkness was pushed back in revealing illumination (Melbin).

Increased security and safety were, of course, the early rationales for nighttime lighting, with the changes in lighting technology rooted in increasing demand for safekeeping in public places. Initially, security meant surveillance. Public spaces otherwise shrouded in darkness were brought into view, and society's commercial and professional elites were more fully enabled in taking jurisdiction over spaces otherwise plagued by criminality. Security meant safety of person and protection of property, but security also came to mean safety in movement. Very quickly, vehicular movement became the dominant concern, particularly with the arrival of fast cars and trucks. Safety then took on the more specific connotation of protecting pedestrians from motorists and motorists from themselves.

The popularity of the automobile and the intense lighting of streets, freeways, and suburban highways, especially after World War II, pushed back the darkness as never before, bringing substantial homogeneity to the lighting of public space (Nye 1990; Platt). Safety in speed of movement, as America's built environments increasingly accommodated the automobile as machine, wrought the unanticipated effect of dulling sensitivity to artificial illumination (Jakle 2001). The purveyors of light, perhaps, were too successful. The power companies, the manufacturers of lighting fixtures, and the traffic engineers combined to create nighttime environments so ordinary, so easily adapted to, and so readily predictable as to excite little special notice. In American cities today the night is never completely dark anymore. Light scatters, reflected off the surfaces of streets and the facades of buildings. It reflects off clouds above with a domelike glow permeating the night as a halo. Greater vehicular speeds and higher traffic densities required extravagant levels of street illumination, especially in commercial areas.

Early on, however, electric lighting served the nighttime city in various ways, the visual impacts of which combined, more or less equally, to define the night as visual display. Light facilitated movement, as has been emphasized, but it also informed, especially through electrically illuminated signs. Signs, of course, also entertained, most often when exaggerated in size and clustered in large numbers as in New York City's Times Square. Light also celebrated. The novelty of bright nighttime illuminations in surrounds of dark shadow struck the unaccustomed eye as spectacular. Nighttime light festivals were held seasonally in nearly every large American city in the years before World War I. The festive use of light reached high perfection in the large expositions or world's fairs and at the nation's amusement parks.

NIGHTTIME PHOTOGRAPHY

Early in the twentieth century, night lighting attracted the eye and impressed the mind as a thing of novelty if not of beauty, the sense of spectacle totally inviting to pictorial representation. Depicting the illuminated night became a challenge for photographers and printers alike. Photographic images initially were converted into engravings and lithographs and later were mass-produced directly as prints, including postcard prints, through photomechanical means. Although some photographers sought highly individualized artistic expression and produced unusual works of art, the bulk of the photography produced in America was, in fact, ordinary whether by subject matter, viewpoint, composition, or other aspects. Postcard photography became conventional, with very common subjects and use of a limited range of compositional devices bringing stereotype and cliché to visualizing the night. Nonetheless, postcard imagery assumed impor-

tance, if not as artistic expression then for its scale of consumption.

Highly standardized postcard images carried a sense of legitimacy when mass-consumed. Mass circulation brought with it an implied sense of authority. Seen over and over again, specific nighttime views, and kinds of views, implied a public stamp of approval, with viewers becoming habituated to set ways of seeing. Visual convention easily was mistaken for truthfulness (Taylor 287). Even crudely printed postcards could suggest verisimilitude. At work was the modernist impulse to embrace standardized, machine-made things as inherently better. Apparent realism coupled with frequency of encounter enhanced the power of conventional postcard representation, setting predispositions to see, that is, expectations that, once set loose, governed visual receptiveness through presupposition.

Introduced in the United States after 1839, photography matured just as gas and electrical illumination in American cities came of age. The camera, for its part, offered what appeared to be a new visual relationship to the physical world. A photograph's "mirrorlike" image seemingly captured historical moments, preserving them in all their uniqueness. Photography became a means of defeating time and endowing memories with permanence (Trachtenberg 288). To its work the camera brought a sense of inscrutable accuracy. What was portrayed could be thought of as real since a camera could not lie. It was a machine that recorded only what it saw. It could not feel. It did not distort through emotion. It was objective. Such thoughts carried over into the American public's appetite for postcards.

Since postcard images appeared realistic to most Americans, even postcards of the night, they offered a substitute for actual seeing, a substitute for firsthand experi-

encing. They offered the viewer ready insertion into a pictured scene, an invitation to spectate as if actually being there. Not only was surrogate experience offered but a kind of surrogate ownership as well. The scene pictured remained frozen, a fossilized afterview to be used and reused, appreciated and saved or, conversely, dismissed and discarded at will.

Subjectivity, indeed, did enter through the instrument of the photographer. Photography was an art. By varying camera angle or by choosing lenses of varying focal lengths, the photographer could produce an infinite number of varied compositions with a single, stationary object. By varying the length of exposure, the kind of emulsion or the method of developing, the photographer could vary the registering of relative light values in a photo negative, and these values could be further modified by allowing more or less light to affect certain parts of an image in its positive printing (Weston 161). Gifted photographers sought constantly to push back the frontiers of both photocomposition and darkroom technique so as not to fall victim to pictorial cliché. Few postcard photographers, though, had the skill or, for that matter, publisher support to so innovate. Most worked within established ranges of vernacular consent in rendering images of ordinary factuality.

The act of photographing was, and is, an act of selection: Which viewpoint to use? Which vista to emphasize? How to arrange visual components of light and shadow? How to frame? The act of framing through the viewfinder modified all of the other decisions. Edges provided demarcation by including or excluding, some things put in and other things left out. Selection might be made by the rote following of established habits of seeing, the meanings invested in photographs little exceeding mere description, or deeper meaning, sometimes obtained by

violating compositional rules, might be achieved and photographs made to speak metaphorically. Inclusion or omission, whatever its purpose and effect, remains the central act of photographic art (Szarkowski 4).

The propensity to see, at least in the modern Western world, involves the embrace of artificial linear or single-point perspective, an artistic development of the Renaissance. Techniques were developed, through set design in the theater and in landscape painting, to replicate graphically the linear perspective of distance. Scenes were depicted as if perceived as whole from a single point of view, and emphasized was an appreciation for both the harmonious and the proportional in pictorial space. Amplified through the camera lens in photography, this Cartesian structure of visual perception became something so familiar and so transparently evident that most people regard it as a natural basis for ordinary observation.

Although numerous artists contributed to what today we generally refer to as "picturesque" landscape depiction, two painters have been singled out. The French painter Claude Lorrain's contribution was to create scenes with multiple horizons: a foreground (often with scattered small objects close to view), a middle ground (often with a lake or other water surface partway in), and a background (usually a far horizon with hills or mountains). The whole was then laterally framed by trees or other large objects to orient the viewer's vision forward. Another French painter, Gaspard Poussin, regularly connected his receding horizons with a series of right-angle turns (curving roads, river meanders, etc.) to thus enhance the visual force by which the eye entered a scene. He created thereby a stronger sense of vista. Most early landscape photographers took their compositional emphases from landscape painting, attempting, if you will, to make their photographs "artistic." Circularity

operated. Picturesque landscapes were depicted in a picturesque mode, thus setting the viewer's mental template or predisposition to see or gaze in selected ways, especially when judging beauty in one's surroundings.

A view, as a complex of objects in visual space, can be categorized according to basic components, including 1) distance over which sight is effective; 2) foreground/middle ground/ background discontinuities (or the existence of multiple horizons); 3) enframement by which sight is bounded; 4) focal points that serve as attention-getters; and 5) a sense of security implicit in visible locales implying safety. In a good composition, objects and intervening voids must, in some measure, conform with each other, sometimes through a hidden geometry of triangles and other shapes or at other times with an insinuating trajectory of curved line, for example. Lines, masses, colors, tones, textures, angles, sequences, or hierarchies must seem to be "just right."

Nighttime photography involved choices different from those of the day. Landscape at night was already severely edited by the darkness, with the subtle play of light and shadow found in daytime photographs reduced to severe contrasts of brilliant light and utter darkness. Primitive cameras and slow photographic plates and films made the stopping of motion difficult — something hard enough to do in the daylight but nearly impossible in the dark of night. Early on, many night photographs were taken by making two exposures: a short one in the diminishing late afternoon sun, in order to secure an image of buildings and other features, and another one well after dark, in order to print in the gas or electric lamps and the pools of light that they cast (Carrington 626). A tripod was absolutely essential, with the camera carefully left in position during the intervening hours.

Night photography was very new when Joseph F. Mullander and Sidney Sprout experimented with nighttime scenes at the Electrical Carnival Night Pageant in Sacramento and then again at San Francisco's Midwinter Exposition in 1894. An "instantaneous exposure" was made of the fair's Court of Honor at five o'clock. The camera was left standing until nine o'clock, and then the lens was opened for fifteen minutes. None of the lighting effects were staged for the camera. Thus, a searchlight beam was "faked" on the negative by means, they wrote, "familiar to every photographer" (Mullander and Sprout 84). "Nonhalation" plates were available to them but were not used. Halation ("halo" being the word's stem) was the "milky waylike haze" created on photographic plates when cameras were pointed directly at a strong light, such as the luminance of an electric arc lamp. Special double-coated plates could be used to partially eliminate the effect, with one coating slow and the other fast (Carrington 626).

Luminance fell off from a source rapidly, at a rate inverse to the square of distance ("Night Photography" 770). Thus lamps, and not intervening lit surfaces, dominated nighttime photographs. Early photos of the night tended to communicate solely as pools of light separated by featureless dark shadows. Of course, this was not what the human eye actually saw at night with its tremendous range of light sensitivity. In after-dark photos, composition involved arranging the glow of lamps in satisfying patterns. Especially useful were wet streets and other reflecting surfaces that mirrored lighting. Contrasts in night pictures could be reduced by eliminating all direct light. By keeping lamps and other light sources totally out of photographs, the subtleties of reflected light could be emphasized through very long exposures. Only with

improved cameras and fast films introduced throughout the 1930s and 1940s did night photography, both black-and-white and color, become less a technical and more an artistic challenge, the contrasts of light and shadow now truly open to photo opportunity.

The use of floodlighting (and later flashbulbs and strobe lights) enabled photographers to fully picture objects in the dark, but such artificial lighting did not capture the nighttime as it actually was. It only captured things lit by a specially created light used for photographic purposes, the act of photographing made intrusive in the night. The arrival in recent decades of ultrafast films, adjusted for the color ranges of specific electric lamp technologies, has greatly encouraged night photography, enabling more realistic imagery. Nighttime picture making has been brought well within range of even the neophyte amateur photographer through the perfection of technically sophisticated automated cameras.

PHOTOGRAPHY AS AN ART

The full challenge of nighttime photography was met initially and primarily by those interested in artistic expression. Most makers of postcards turned instead to doctoring daytime photos, manipulating them to appear as nighttime scenes. Although there was an art to photo retouching, such license only served to undermine artistic photography's more serious intent, reason enough for historians of photography to generally ignore postcards as a legitimate photographic form and to view them as even demeaning the larger photographic enterprise. When compared to the painting of canvases, even serious photography lacked full respect. Painting required the skill of a dedicated craftsperson who hand-manipulated his or her

materials, informed by an eye educated in an elaborate culture of illustration. Photographs, as it was commonly put, were "taken." Presumably, anyone with a camera could do it.

Perfection of the snapshot camera only heightened photography's demeaning as an art form. Amateur photography came of age with George Eastman's introduction of the Kodak camera, a small hand-held affair easy to operate: the first "point and shoot." The word *snapshot* implied how easy it was to take pictures. Like a hunting rifle, one had only to lift the camera and "snap off" a shot. Early cameras came loaded with roll film. Once the film was exposed, the camera was sent to Rochester, New York, where it was reloaded for another round of use and then sent back along with the finished prints. Indeed, anyone with a modicum of money and patience could become a taker of photographs.

There developed a group of earnest proselytizers for "photography as art," designated by historians of photography as the "pictorialists." They strove to demonstrate that photographic prints, like paintings, could contain evidence of an artist's handiwork. Photographs needed to look as if they were rendered skillfully by hand, the triumph of an artist's imagination rather than of his or her tools. For the pictorialists all that mattered was the final print: the individual image mounted, framed, and exhibited. Subject matter, the scene or object depicted, no longer counted as much as its treatment (Trachtenberg 183). Pictorialist techniques were many. The rendering of texture and the control of tone through adoption of novel printing papers assumed central importance. The rendering of fuzzy surface and vagueness of outline followed the visual effects created by impressionist painters. The extreme pictorialists dematerialized objects with distorting lenses, gauzes, and

atmospheric mists. American postcard photographers were not totally immune from such influence. While rejecting visual fuzziness, they nonetheless adopted many of the compositional devices perfected by the pictorialists.

Alfred Stieglitz, Edward Steichen, and others, while softening reality through special lenses in the interests of sentiment and mood, rejected the total distorting of the visible world (Green 21). Known as the "photo-secessionists," they sought romantic dreaminess and detachment more in the actualities of unusual light conditions: the light distortions of rain or snow, the diffused nature of twilight, and, of course, the varied luminances of artificial nighttime lighting. For Stieglitz the camera was an instrument of revelation. It was a means of transcending the ordinary in the representation of common things. Photography was a "meditative act," the principal purpose of which was to bring to view that otherwise unseen. In addition, that seen could be redefined as metaphor, an attributed identity or a perceived correspondence useful in converting the particular into the universal (Conrad 77).

Darkroom work with contact printer and enlarger was as important as the imaginative use of the viewfinder. The rendering of photographic images with printing presses also required artistic diligence. An array of technologies — from straight photogravure to one-, two-, and four-color halftones to collotypes—led the way in the pages of Stieglitz's magazine *Camera Work*, published between 1903 and 1917 (Jussim 37). Like the pictorialists, the photo-secessionists emphasized the finished product but, again, not to the disregard of the subjects portrayed. Indeed, a concern with realistic portrayal assumed importance, especially with the rise of Paul Strand and his students. Casual seeing was disparaged. Invited was the fully perceptive eye through studied involvement with objects in space defined at various scales, including that of landscape and place.

Strand's contributions were many. Most photographs followed the proportions and perspectives of normal vision. Photographic images represented the world more or less as people might see it themselves from normal viewing distances. Strand dramatically "closed the distance" between the eye and the thing seen by moving his camera close to objects thus "decontextualizing" them (Orvell 215). Exaggerated enlargement invited discovery. It produced new insights even with the most mundane and ordinary subjects. Important for landscape photography, including night photography, was a focus on the commonplace and even the vulgar. Photographers thus were invited to explore the world not just as a container of the romantic, the picturesque, or the otherwise tasteful.

Focus was given to the vernacular of American landscape and place. While pictorialists were out looking for poetic brooks at sunset, Strand was photographing lines of telegraph poles or trees outlined against an evening sky or a busy city intersection filled with pedestrians and vehicles (Orvell 215). Strand emphasized common subjects as if heeding essayist Sadakicki Hartmann's call in *Camera Work* to explore the landscapes of the new modern world evolving. "The main thoroughfare of a large city at night," Hartmann wrote, "near the amusement center, with its bewildering illuminations of electrical signs, must produce something to which accepted laws of composition can be applied only with difficulty" (200).

Emergent also was documentary photography that emphasized realistic depiction. Documentary photography did not merely describe but advocated a belief or an action. Its intent was not merely informational but was meant to dramatize thinking about a subject (Guimond

7). At its best, it enabled viewers "to see, know, and feel the details of life, to feel oneself part of some other's experience" (Stott 8). Enframed were scenes into which viewers were invited to visually enter and move around and explore, thereby engaging directly in a story being told. The art of documenting landscape with the camera was encouraged by exploration of the American West. Such photographers as Timothy H. O' Sullivan, Carleton E. Watkins, and William Henry Jackson were engaged in government-sponsored surveys or they took it upon themselves to document life and landscape on and beyond the settled frontier. Their work often took on scientific implications as in the objective recording of plants, animals, and landforms. Most photographers brought to their work rules of pictorial composition rooted in landscape painting and also in portraiture, rules that encouraged the depicting of the grand and the profound. Photographs were produced as cabinet cards and stereographs for a mass audience curious about the nation's western reaches (Hales 1988; Naef and Wood). Excited generally was a market for sweeping topographic views.

Perhaps no American photographer ever exceeded Walker Evans in mastering documentary photographic art. Evans's signature was the frontal attack, with buildings as well as people depicted straight on with clarity and force. Textures stood out. Silhouettes were sharp. Forms and shapes were balanced in unobtrusive geometries of composition. His images excited the eye as they told their stories of, for example, American workers in photographs commissioned by the Farm Security Administration (FSA) during the Great Depression of the 1930s (Hurley; Maddox). Evans was enamored of postcard views, since they also offered straightforward depictions of landscape and place. It is not unreasonable to think that postcard art

might even have influenced Evans's photography. None of his FSA photography depicted the night, yet it struck responsive chords in many of those who did. For example, Weegee (who nicknamed himself after the Ouija board) produced in the 1940s and 1950s photographs and motion pictures of the urban night, specifically in New York City. People and places were set in garish outline through use of the uncomplimentary flashbulb. Of course, Jacob A. Riis, among others, had pioneered decades earlier the use of "flashlight" in documenting society's underclass at night (Riis). Whereas Riis's photographs were intended to persuade Americans to accelerate social reform, Weegee's were intended to titillate and shock. Both represented a kind of privacy-shattering, scrutinizing gaze well beyond the ordinariness of postcard art.

Documentary photographs were not meant to be entertaining as postcard images were intended to be. Rather, they sought to authenticate by letting the viewer know and feel something of the details of lives shown. They let the viewer feel a part of someone else's experience, the experience of those depicted if not the experience of the photographer as investigator. Factual illustration, as postcards pretended to be (and often were), was thought useful but not very stimulating in and of itself (Stott 8). As visual commodity, the postcard lacked the seriousness of intent that documentary photography asserted. The postcard invited only the casual rather than the serious gaze.

DEVELOPMENT OF THE POSTCARD

The postcard exploded on the American scene after 1900. In 1906, an estimated 770.5 million postcards were purchased in the United States, with post offices in New York City alone processing some two hundred thousand

cards during February of that year (Guimond 8). In 1913, the estimated number of cards purchased in the United States stood at nearly one billion (Miller and Miller 22). These numbers were immense when compared to photographic images otherwise consumed. The sum total of photographs published annually in the nation's illustrated magazines could not compare. Photographs appearing in *Camera Work* and in other art magazines or displayed in art galleries or otherwise celebrated as works of art were absolutely insignificant in comparison numerically. The numbers of postcards mailed were all the more impressive when one stopped to think that privately printed postcards were not legal in the nation's mails until 1898.

Cabinet cards provided early precedent leading to the postcard. They were actual photographs mounted on cardboard to be displayed and stored in albums, with views of natural landscape (especially western scenery) and cities dominating. Also popular were stereographic slides, that is, photographs mounted in pairs to be viewed with three-dimensional effect through hand-held stereoscopes (Earle). Sold individually or boxed in sets, stereographs could be found in the parlors of nearly every affluent household by the end of the nineteenth century. They offered views of the nation and the world, the realism of which was greatly amplified through "3-D" vision. Important also were so-called "contextual portraits" that depicted people not in photo studios but in the out-of-doors, standing or sitting in front of family dwellings or places of business.

Cards with mechanically printed landscape scenes predated photography. Examples included playing cards, calling cards (or *carte-de-viste*) and trade cards. Similarly, pictorial writing paper and envelopes sometimes carried landscape depictions. Photography impacted the printing of such graphics through a supply of visual "copy" for illustration, with photographic images necessarily transferred onto printing blocks or plates for mass reproduction. At first, woodcuts and metal engravings dominated. Pictures were cut in reverse in wood or metal and then inked; finished prints were made by impression upon paper. Important also was lithography, a printing process based on the immiscibility of oil and water that used porous limestone blocks. On a slab of polished stone, a picture was drawn in reverse with a greasy crayon, with the acid of the grease imprinting the pressed paper. In color lithography, a different stone was prepared for each color imprint, with the paper variously reprinted to achieve the desired color effects of blended hue. In the 1870s, lithography was mechanized with high-speed offset presses. Throughout the 1880s and 1890s, steady innovation facilitated the transfer of photographic images onto printing plates through chemical etching ("Photo-lithography" 840).

Four principal processes of photomechanical reproduction were operative throughout the early twentieth century: photolithography, collotype (including albertype, heliotype, and artotype, among various trade names), photogravure, and halftone. The first three were little used in postcard printing since their plates were short-lived and incapable of long, continuous press runs. Collotypes used so-called "photo-gelatine" techniques, inked gelatine printing surfaces secured on glass or stone (Welling 85). With photogravure, copperplates were engraved through photographic sensitizing, making possible the use of transparent inks of soft color and thus producing prints much appreciated in art photography.

Most important to postcard makers was levytype, or halftone. A screen was used to break up a photographic

image into patterns of various-sized dots; the "dot-images," in turn, were reproduced on metal plates through chemical etching. Pictures thus were outlined in dot patterns, with patterns of small dots producing light tones in prints and patterns of large dots producing dark tones. All dots, however, were so small that the human eye saw only a general effect, an illusion of shading. Plates were capable of producing prints by the tens of thousands; therefore, halftone printing became the standard not only for postcard publishing but for the publishing of magazines and newspapers. Full-color reproduction required a four-color process in which successive impressions were printed in yellow, magenta (red), cyan (blue), and black ink (Schultz and Schultz 70).

The postcard originated in Europe. "Correspondence cards" were first accepted in 1869 by the Austro-Hungarian postal service, followed the next year by the North Germany Postal Confederation and the British Post Office. Sold were specially printed cards, with postage included in the price. Space was reserved on the front of each card for a mailing address and on the back for written messages. The United States followed suit in 1874 but only with official "postal cards" sold in bulk at post offices since the right of sale was reserved by the federal postal authorities. At first, cards were issued in two sizes, the larger for men or business and the smaller for ladies or casual correspondence. In 1893, a single size (3½ by 5½ inches) was made standard. Arguments put forward in support of correspondence cards included the following: Being smaller than letters, less postage might be charged, making postal service cheaper. When used in mass mailings, cards substantially lightened the mails. Cards stood ready for quick and easy dispatch and thus represented a convenient means for ordering goods or for

otherwise conducting routine business. They aided the harried traveler by substantially reducing the amount of time and money required in writing family, friends, or business associates when "on the road."

Beginning in 1861, the U.S. Postal Service had accepted such cards with preprinted messages, mostly advertisements. Postage stood at two cents, the same as for letters in envelopes. The legislation of 1893 legalized "private mailing cards," and the price of their postage was set at one cent. The word *postcard* was adopted in 1901 to differentiate the new card from its official "postal card" predecessor. At first, written messages were reserved to a card's back side, but after 1902 messages were allowed on both sides, setting the stage for the postcard's mass popularity. The mailing of view cards was first popularized at the Chicago Columbian Exposition of 1893. At the St. Louis Louisiana Purchase Exposition of 1904, postcard fever reached epidemic proportions: the fairgrounds was provisioned with scores of mailboxes intended specifically for postcard mailings.

The enthusiasm for postcard communication excited commentary both pro and con. Many critics were concerned that cards exposed private correspondence to public view, inviting violation of privacy and vulgarity through public display. Use by tourists to write quick messages was seen as demeaning to the very act of travel. "Time was, when no flying picture post cards ticked off the successive stops of a hasty 'run' abroad," mused Richard Steel in a letter to the *Atlantic Monthly* in 1906. Formerly, a traveler would have sat down with "quill pen and innumerable sheets of impalpable paper" to write at length about his or her experiences. Now the traveler succumbed to the "insidious temptation" to dash off a "pernicious card" (Steel 288). With meager space for messages,

postcards only encouraged mental laziness, undermining letter writing as a literary form. "The superior person despises the picture post-card," wrote an anonymous contributor to Britain's *Macmillan Magazine,* a letter reprinted in the United States in *Living Age* in 1904 ("The Picture Post-Card" 310). To others it was not so much the sending but the collecting of cards that worried. The artisan classes were tempted, through pictured views, with "dream-traveling," a "gratification of the imagination without the exercise of taste," wrote one critic ("The Picture Post-Card" 311). Thus, postcards were seen, by at least a few, as symptomatic of a general leveling of society as well as the demise of refined cultural sensibility.

Still, opening the world to middle- and lower-class "gaze" excited most Americans as something very positive. Even so, popularization of the visual arts seemed to require defending, and many celebrated artists and authors did just that. Theodore Dreiser, accompanied by an illustrator-friend, motored west from New York City in 1915 on a nostalgic return to childhood haunts in Indiana: "a Hoosier holiday." Repeatedly, Dreiser marveled at the postcard views available in small-town stores. They helped him capture a sense for the character of localities visited, what some observers might call "sense of place." "I liked the spirit of these small towns, quite common everywhere today, which seeks out the charms of the local life and embodies them in colored prints, and I said so." "Walk into any drug or book store of any up to date small town today," he continued, "and you will find in a trice nearly every scene of importance and really learn the character and charm of the vicinity" (Dreiser 448). James Agee, writing some forty years later, struck a similar chord. Emphasizing that the "busiest and most abundant sense is that of sight," and that sight had been greatly amplified by the visual arts, especially photography, he went on to assert that of all popular photographic forms the most useful was the city postcard (v).

POSTCARD PUBLISHING

Perhaps the most exquisite postcard prints ever marketed were made by the patented "photochrome" process developed in Switzerland in 1890. It was used exclusively in the United States by the Detroit Publishing Company, the firm that William Henry Jackson joined in 1898, bringing his extensive collection of western cabinet card negatives for reuse as postcards. The photochrome was not a color photograph, although it served that purpose in the days before commercially feasible color films, nor was it the usual screened halftone print. It was a continous-tone color rendition of a black-and-white photograph that used multiple impressions from printer's plates, upward to fourteen in number. The process was very labor-intensive. Prints were made on hand-operated flatbed presses capable of producing only a few hundred impressions an hour. Although the secret to the process's clarity has been lost, speculation is that the color was put down on black-and-white photographic prints.

In Europe, postcard photography was greatly influenced by pictorialism's devices. Prints of very high quality, like photochromes, were possible given the exceedingly low labor costs there. Through 1920, therefore, most of the better-grade color postcards marketed in the United States actually were printed in Europe, particularly in Germany. In the United States, standards were not so high regarding printing quality, with publishers favoring fast, largely automated halftone printing. Perhaps Americans were less discerning. The American market, being broader

than the European, required publishers to combine lower common denominators of taste with cheaper products. Americans settled for more crudely rendered views. In Europe, postcard skies seemed always dark and filled with fluffy, cauliflowerlike clouds. Night scenes seemed always to feature subtle skies with clouds backlit by moonlight. In the United States, the viewer of postcards was required to take depicted scenes with something of a sense of humor because of the obvious simplifications and crude disjunctions visually obvious.

In the 1920s, the precise pastel prints of the Detroit Publishing Company were replaced in the pantheon of American postcard art by the substantially retouched, vivid halftones of the Chicago-based Curt Teich and Company. Most of that firm's postcards were printed on heavy-textured linen paper. A black-and-white print, sized eight by ten inches or larger, was retouched, glitches in the negative were removed, but, more importantly, the picture was altered by way of "improvement" (Ripley 129). Unsightly objects might be eliminated or pictorial elements added to reinforce the composition. On a tissue paper overlay, color codes were outlined. Often a hand-drawn and hand-colored sketch was attached not only to instruct the printer but to submit to the client for final approval prior to printing. The largest companies, such as Curt Teich, claimed not to be postcard publishers; rather, they saw themselves as printing cards for clients: small publishing houses, local news agencies, and businesses large and small nationwide, especially those in the tourist industry. Of course, company salesmen regularly went along established routes in set territories to solicit such business. Although the customer usually was designated on the back of a card as the publisher or copyright holder, it was, in fact, the company's product.

The photograph to be printed was converted into a number of halftone plates, one plate for each intended color. Plates were grouped for "gang runs," with the cards of several clients (or a variety of views for a single client) printed together on long rolls of paper. Mechanical guillotines then cut the sheets by stages until individual cards emerged to be packaged and mailed. Photographic postcards—prints developed directly on photographic paper—also were mass-produced. Rolls of sensitized bromide photo paper were exposed to light through negatives grouped in printing frames carried mechanically through the tanks of developer and fixing solution to a drier and then on to cutting blades. The ability to operate with press runs in the thousands, if not the tens of thousands, greatly reduced costs, enabling a profit margin of a fraction of a cent on each card. Rarely did postcards sell for more than a nickel prior to World War II.

Many clients, in particular local news agencies, served as wholesalers by distributing postcards to retailers, who, in turn, sold them across sales counters or off of postcard racks. After 1920, drugstores became the most popular venue for postcard sales. Business clients, conversely, made their cards available free as "carry-away" advertisements or in promotional mailings. News agencies tended to commission general views, marketing card sets that depicted localities. Merchants tended more to commission architectural illustrations, especially pictures of commercial facades. Hotel operators, for example, came to use postcard advertising as a matter of course.

Glossy black-and-white postcards, now called "real photos," competed with color-printed cards, especially in small-town markets largely overlooked by corporate card agents. Many local photographers sold, or prepared for others to sell, a postcard series to complement their por-

traiture and other work. Cards were actual photographs produced in relatively small batches on postcard-sized photo paper in studio darkrooms. After 1939, postcards also were produced from Kodak color negatives commonly called photochromos, making it possible to capture realistically in color the subtle contrasts of nighttime light and shadow without resort to ultraexpensive photomechanical printing. Color processing, however, required expensive equipment, favoring once again mass-production and operations at the scale of the large corporate printer. After World War II, photochromos rapidly came to dominate the American postcard market, and Curt Teich, for example, converted fully.

In the United States, as in Europe, postcard art owed much to what has been called "grand style" photography (Hales 1984, 71). Broad-sweeping urban panoramas were offered from up high or oblique views from looking down onto city streets. Frontal depictions, usually of large buildings, also were calculated to impress, to strike in the viewer a sense of admiration for the scale, if not the refinement, of that depicted. Orderliness was emphasized, the sense that everything was in its proper place if not perfectly in balance. Not only was a sense of grandeur intended but a sense of civility as well. Pictured was the significant architecture by which cities were meant to be known as places of taste and refinement. In folio books with expensive bindings, photos in the grand style not only depicted cities but, taken in the aggregate, they helped define a mythic America of cosmopolitan grandeur.

Folio books owed much to the topographic artists of the nineteenth century. In engraved bird's-eye views, with street scenes and architectural renderings often inserted around map margins, artists likewise had sought to strike a sense of awe in the eye of the city beholder (Schein 7). Topographic views offered expansive city "tableaux," cameolike urban poses (Boyer 2). As with engraved views, sold largely to a city's more affluent classes, the photo-portfolios sustained a decidedly elitist view of the American city. Emphasized were the monumental structures of corporate capitalism (symbolizing economic power), elite philanthropy (symbolizing culture), and government (symbolizing civility). Largely missing were images of a city's dispossessed or, in other words, its problem classes. Underrepresented, or not represented at all, were images of the American petite bourgeoisie, the nation's artisans and small shopkeepers.

In contrast, postcard art did embrace the lower middle classes as a subject for depiction, if only to show ordinary Americans as pedestrians crowding city streets. Postcard photography could be said to have democratized the urban view, embracing as it did the more commonplace alongside the monumental. In part, this emphasis was encouraged by the rise of amateur snapshot photography. Tied substantially to the picturing of families in home and in recreational settings, especially those of tourist travel, amateur photographers took to self-celebration with their hand-held cameras. For vacationers, the snapshot camera offered an opportunity to record places visited, validating them in visual trophies to be shown to friends and relatives. Postcard publishers and their clients came to view their product in the same light as commercial "snapshots" of landscape and place for tourists without cameras. Postcards very quickly came to emphasize scenes of touristic value. Postcards promoted the tourist gaze.

In 1902, the Eastman Kodak Company introduced postcard-sized silver-chloride papers on which images could be printed directly from negatives (Kouwenhoven

161). Called "gas light" paper, it was sensitive enough to be printed using ordinary artificial light. Photos could be developed and fixed through very easy chemical application. Some paper did not even require fixing. Stamped with the requisite "postcard" designation on the back, tourists could use such paper to make their own postcards in their hotel rooms. Also, negatives could be developed in hotel bathrooms using small film tanks.

Most tourists preferred not to make but to buy postcards, and there were few tourists who did not buy them, even those who carried their own cameras. Many Americans, denied the opportunity to travel extensively, collected postcard views instead. The postcard easily masqueraded as travel, as had the stereograph before. Stereographs continued to entertain and instruct Americans well into the twentieth century, but postcards greatly diminished their market. Although postcards were not as realistic, they were much easier to handle and substantially cheaper to buy. What one missed in quality of visual impression one made up in numbers. Promoted was the same voyeuristic relation to the world. Invited was the same acquisitive impulse through collecting. Encouraged was the compulsion to categorize and collect one's experiences in the world as traveler or as potential traveler. Postcards helped Americans imagine the world as geography, the world transformed into a collection of pictorial destinations. "Countries were reduced to a litany of great cities, and great cities were reduced to a checklist of prominent buildings, historical monuments and scenic viewpoints" (Schwartz 33). It was, perhaps, the armchair travelers who embraced postcard collecting most faithfully, a hobby that would come to be called "deltiology" (from the Greek word for a small writing tablet). Clubs formed across the United States primarily to promote the exchange of cards. Postcard publishers aided and abetted by selling their postcards in numbered sets.

NIGHTTIME POSTCARDS

Postcard publishers engaged freely in the alteration or manipulation of photographs, producing highly "fictionalized" pictorial art masquerading as realistic. Touch-up work produced cleaner, simplified images, making the places pictured seem less complicated and tidier and, perhaps, more salable as postcard views. Conversely, places might be made to appear more complicated and thus, presumably, more interesting. Historian Alison E. Isenberg has emphasized the role that the doctored postcard played in portraying cities in the grand style (128). By eliminating the evidences of overhead power lines, unpaved streets, and lack of curbs and sidewalks, for example, cities could be made to appear more aesthetically pleasing and more modern and up to date. Such manipulations in postcard art, Isenberg argued, anticipated and, indeed, helped promote actual physical change in cities. Promoted was a kind of visual modernism suggestive of a better future. Many if not most postcards, she concluded, were a "composite of fantasy, boosterism, wishful thinking, simplification, and outright lie" (128). Especially was nighttime postcard depiction a product of revision. As a matter of fact, most nighttime views were contrived from daytime photographs and were not, strictly speaking, nighttime photos at all.

Among the earliest attempts to picture the night in postcards were the "hold-to-light" cards, sometimes called "moonlight" cards. Such views looked like normal daytime scenes but were printed with dark overtones of indigo blue, a large moon usually inserted in the sky.

Daytime seemed to change to night when the card was held up to strong light. The top layers, of what were invariably multilayer cards, were pierced with pinholes, with the light seen through the holes giving the impression of brightly lit windows, brilliant streetlights, and other sources of emitted light. In contrast, the remainder of a scene seemed to retreat as shadowy background. Publishers experimented with various backings and with larger cutaway sections to make cards more transparent, simulating not only emitted light but reflected light as well. Hold-to-light cards were first popularized in the United States at Buffalo's 1901 Pan-American Exposition, the first of the world's fairs to fully emphasize nighttime illumination, a theme that publicized the city's proximity to Niagara's hydroelectric power.

Before the introduction of fast films, night photography required long exposures, with movement impossible to picture except as a blurred streak. Today, the open lens, calculated to blur the moving headlights and taillights of automobiles, is a popular means of depicting traffic flow in cities. Early in the twentieth century, though, such distortion was unacceptable. It could be avoided by photographing very late at night when streets were empty. "Dead-of-night" scenes, however, lacked life. What needed to be portrayed of nighttime cities was not emptiness but activity. The real challenge also was to represent the nighttime city with all the excitement that artificial illumination encouraged in public outdoor spaces. The challenge was to capture the illuminated night's sense of spectacle.

Most nighttime postcard views were daytime photographs doctored to appear as if taken after dark. Use of daytime photos to replicate the night introduced many anomalies in finished cards. For example, daytime shadows often remained. When a bright moon was inserted in a darkened sky, the moonlight implied was often inappropriate to the shadows depicted. Especially problematical were the small shadows cast by pedestrians and vehicles, their impossibility of angle all too apparent. As one deltiologist noted: "Darkening the sky, lighting the windows, and adding a moon could . . . turn a day scene into a nocturnal one, but all too often the printer failed to remove the shadows cast by the sun and then tipped his moon in an obviously impossible position" (Ryan 146). Other anomalies included American flags left flying (countering prohibitions on after-dark flag displays) and kinds of people remaining as pedestrians, especially unescorted women, who would not have been seen in big city downtowns after dark.

The simulation of nighttime scenes through retouching invariably involved inserting things into postcard views. Elaborating the nighttime sky with a cliché moon was all too common. Without something in the sky, though, one-third or more of a view would show as little more than dark void. Inserting fictional searchlight beams was another way of filling such emptiness while, at the same time, amplifying a sense of nighttime excitement. The picturing of signs, particularly advertising signs, invited color enhancement. Sometimes fictitious signs were inserted to enhance the composition. As in an actual landscape viewed at night, signs in a postcard view could serve as focal points or as part of a patterned light array. Realistic depiction of giant sign spectaculars required splashes of vivid color. Postcard printers were hard pressed to do New York City's Times Square full justice, especially after neon was introduced. Photographs could not fully communicate the titillating animation of leaping cartoonlike characters and flashing lettering sequenced to spell out words. Neon tubing could be depicted but not its reflective glow off surrounding metal surfaces, at least not until

photochromos came to the fore. There were limits to the photo retoucher's ability to simulate the night.

The most important kind of light enhancement involved the picturing of streetlights. Most postcard scenes were composed with a view along a public street, the vista of the street the most widely used of all compositional devices. Lit streetlights reinforced nighttime avenues as forceful linear arrays. Thus, early in the twentieth century, before actual installation of modern streetlighting in some cities, postcard publishers inserted fictional streetlights both to improve photo composition and to represent the kind of lit street that card viewers fully expected. Postcard buyers valued visual spectacle. City boosters valued spectacle when it spoke of modernity and prosperity, which all public lighting surely did. If a city scene disappointed, postcard dubbing offered respite. Better not to depict the urban night as dark actuality when it could be depicted as bright possibility or, better still, as bright eventuality.

Postcard publishing served city boosterism through appeal to pride of place. Accordingly, postcard publishers sought to depict localities in their best possible "light." Above all, cities needed to look prosperous. Vitality and growth were signified in the up-to-date infrastructure of monumental buildings, but so also did streets need to look "grand" and to bustle with traffic, especially motorized traffic. Postcards might celebrate the uniqueness of an urban locality, but, more importantly, they needed to depict that which typified a city as being fully up to date. Postcard views needed to fit each depicted city firmly into the nation's set of truly progressive urban places. In the case of depicted streets, this meant eliminating unnecessary clutter, particularly things that detracted visually and spoke of obsolescence. Evidence of antiquated rusticity, especially the slovenliness of neglect, absolutely required expunging.

Outdated views did not sell well, and views that emphasized outdated things did not sell well either. Apparent obsolescence sent negative messages in a society that saw newness as a sign of improvement. Americans were future-oriented rather than backward-looking. Thus, many Americans looked at their cities in a jaundiced way. They tended not to see things as they were so much as how they were intended to become, to emphasize change not only specifically planned for a near future but, as well, change only vaguely anticipated over the long run. Pervading American society was an optimistic belief in progress technologically driven. Therefore, one needed to see pictured, especially in postcards, things that symbolized progressive change. Old things depicted were not totally without value, but historicity tended primarily to serve as contrast, to serve as evidence of just how far a city had come in modernizing. Historic landmarks did not speak directly of economic prosperity so much as indirectly through allusion to cultural improvement if not political superiority, the sustainers of prosperity. The historic landmark, depicted as illuminated at night, served as a kind of cultural beacon offering subtle, underlying narrative for city boosterism.

Substantially, it was a male rather than a female bias that underlay nighttime postcard depiction and, indeed, postcard depiction generally. Postcards emphasized downtown scenes, and the American downtown was largely a male-dominated place so far as conduct of the nation's business was concerned. Jobs for women, typically as clerks in department stores or typists and secretaries in offices, and the increasing importance of women as purchasers and as consumers brought more and more women downtown. Still, business ownership and management remained largely a male prerogative. The design and construction of

big city downtowns, both through private and public development, remained largely male endeavors. So also was control of the media, including postcard publishing. From soaring skyscrapers to impressive downtown avenues, it was a masculine world of power that tended to be displayed in postcard views. The domestic side of the city tended not to be celebrated. Residential spaces, where women functioned as wives and mothers, were not emphasized.

Nighttime postcard depiction offered ready connection with American cities after dark. Provided was nighttime lighting's visual representation, the visual delights of lit places rendered as landscape view. Offered was a nighttime gaze fully attuned to modern place making. Packaged was visual spectacle, entertaining in and of itself but evidence as well of a city's and a nation's progress in the civilized and civilizing march to a better future. So also was the postcard a creation of the modern age, a technical triumph in its own right. The postcard was enabled by elaborated national postal systems based on railroads and steamships linked worldwide. Postcard communication was not only dependable but was rapid—and it was cheap. It invited quick and thus frequent intercourse, even of the most trivial and inconsequential "wish you were here" kind. The postcard inculcated American life in a fully modern way. Additionally, the postcard was a product of modern printing techniques and utilized the photograph, itself one of the marvels of the modern age.

A mailed postcard view invited the viewer, both the sender and the recipient, to merge that depicted with a sense of self. Offered was a kind of casual visual experiencing, images composed and presented for quick comprehension. Encouraged was a sense of personal identification with that which was pictured, an internalizing of the world beyond, not necessarily as it was but as it might be seen to be. In postcard views, the gaze of the flaneur was turned squarely on the city as landscape and place. It was turned on built environment that spoke of the economic and political agendas of society's commercial elite. Early-twentieth-century nighttime postcard views necessarily emphasized artificial illumination, inviting, thereby, spectator connection to specific places and to specific kinds of places in the night. From a view held in the hand, one could vicariously enjoy kinds of place experience still novel. In nighttime view cards, landscapes after dark, visual images thereof, the gaze of the spectator, and the ideology of modernism could conflate, merging as personal knowing.

We will never know exactly what it was that Americans in the past learned to see by viewing postcards. We can only assess the postcard art that they consumed. We can assess the formulas of composition that repeated as standard views, especially the pictorial schemes used to draw and fix the eye. One can explore, in other words, the "repeated formulas" that postcard publishers used in shaping popular expectations about nighttime urban landscape and place. Postcards, perhaps more than any other source of visual imagery, ordered the urban landscape unlike anything that had preceded it (Harris 73). Postcards, of course, dealt with the actual, but, as photographs, they substantially filtered what was communicated. They focused attention on some aspects of the nighttime city while diminishing or eliminating other aspects. They isolated what ought to be seen and, in documenting it, claimed special significance for it, meanings that went deeper than simple description.

In the 1970s, historic postcard views flooded onto the market. It was the early-twentieth-century generation

reaching its seniority. Suddenly, postcard collections, dutifully put together by America's seniors in their youth and even as adults, became available through estate auctions and estate sales to retail through used bookstores and antique shops. A new although much milder round of postcard enthusiasm was excited. The collecting of antique postcards is now supported by its own commercial infrastructure, including collector's shows held annually around the nation as well as numerous websites for Internet buying. The historic postcard view has become very much a commodity with intrinsic value as an antique artifact.

Of course, passage of time gives everything value in the marketplace as a function of increased rarity. However, as emphasized here, dated postcard views have value for other reasons. Most importantly, they offer a backward glimpse across the breadth of a past century. They allow the inquisitive mind to explore former times to see, for example, how the urban night might have looked or how it was thought to have looked. A dated postcard view provides a priceless window on the past.

Postcard views set expectations for personal firsthand experiencing and served as souvenirs in remembering places actually seen. It is true that some photographers, dedicated to creating fine art and/or precise documentary records, raised the quality of their photography to a high level. What most Americans were exposed to, however, and what they used in constructing mentally the visual realities of their lives tended to imagery of only modest accomplishment. Predominant were postcard images mass-produced through one or another printing process, with similar views emphasized from city to city but with images of the largest cities, such as New York City, often setting precedent.

Although postcard publishers substantially altered photographs in depicting the night, alterations, even of the most overt kind, did serve to communicate what could be seen, and what should be seen, in the illuminated world of urban America after dark. Postcard representation was not intended to be absolutely accurate as a fully realistic inventorying of landscape and place. Rather, postcards, especially those of the night, were intended to be suggestive. Plausibility was the ultimate test. Was a view credible? Was it believable? What sold best was not necessarily that which depicted reality with the greatest accuracy or precision. What sold best was that which sustained prevailing myths of American advantage and greatness. Popular were the views that spoke aggressively of modern nighttime spectacle.

Even after fast lenses and high-speed films enabled truly innovative nighttime photography, postcard publishers continued to depict the same kinds of urban view as previously and, as well, to depict light in traditional ways. Perhaps a culture of ingrained visual predisposition served to exert a tyranny over what could and should be depicted: the vista of the street, the bird's-eye view, and the boldly pictured facade, among other elements of compositional formula, dominating. Traditional formulas, in other words, continued to underpin America's postcard gaze, but then again, other media, especially the cinema and television, had come to the fore in many ways better equipped to depict America's cities at night and to do so in innovative ways. It is true that post–World War II postcards did not require of viewers quite so much imagination as before. Substantially discontinued were the games of make-believe and future anticipation that postcard publishers earlier had played with customers. Yet, while early-twentieth-century postcards had not been fully truthful, neither had they been completely dishonest. They did order the night in ways that, for most Americans, made sense.

*W*hat is noticed in a picture, and the meaning that it evokes, varies, of course, from viewer to viewer. Landscapes and images of landscape offer "to whom it may concern" messages to be variously read. Nonetheless, most viewers of a postcard can agree, at least in general, as to what is pictured and can share consensus as well as to the pictorial and compositional devices at play. It is, perhaps, in the assigning of social significance that difference of opinion enters most forcefully. Each of the postcard views that follows depicts an American urban landscape: a built environment of solid structures and open voids, with objects and spaces variously related often in repeating patterns. Each view is structured from a specific kind of viewpoint: sometimes an elevated view (looking out and across a city's rooftops or down and into a city's streets); sometimes a view from the ground looking up; but most often a view at ground level looking straight ahead (in simulation of what an ordinary pedestrian or motorist might see in walking or driving along a city street). Each postcard image carries nighttime implications with contrasts of light and dark influencing, and often dominating, that which is depicted. Evident are repeating compositional formulas, and thus questions emerge: Is there a particular kind of visuality playing out? And, if so, what might it have meant in the past? How might nighttime postcards have encouraged viewers to think about the early-twentieth-century American city after dark?

A GALLERY OF POSTCARD IMAGES: AMERICA'S URBAN NIGHT, 1905–1975

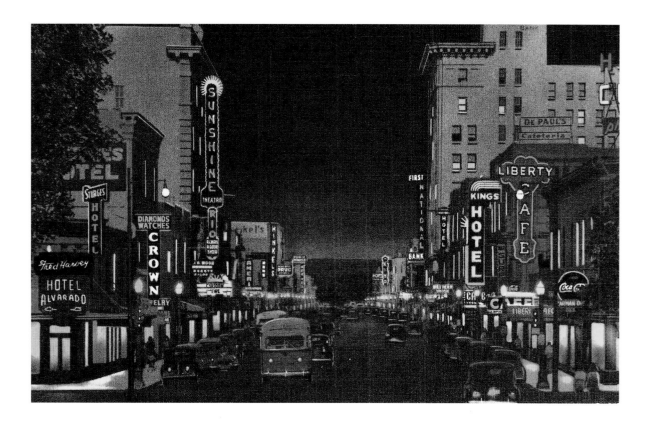

Cities were important travel destinations given their concentration of recreational and other attractions, including the excitement of night lights. Pictured here is where Route 66 traversed Albuquerque's downtown. For those who motored across country, cities were convenient places to overnight. A cryptic message on the back of this postcard, mailed in August of 1951, reads: "Arrived here this evening. A good day's drive—not so warm. A big rain, first in ages. Saw our first mountains. On to Grand Canyon tomorrow." The collecting and sending of postcards became commonplace and, as such, something to be taken fully for granted. Yet no other source of photographic imagery contributed more, at least in the early twentieth century, to how Americans imagined their cities to be.

ALBUQUERQUE, NEW MEXICO. CENTRAL AVENUE, CIRCA 1950.

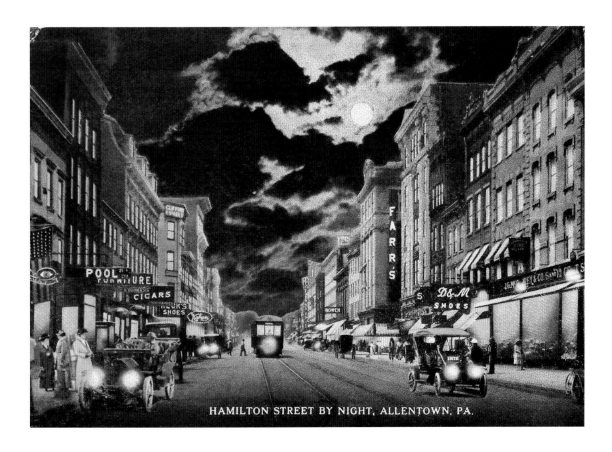

HAMILTON STREET BY NIGHT, ALLENTOWN, PA.

*E*very postcard carried social meaning. Here is Allentown's principal retail street on a shopping night, with store windows and signs brightly lit to entice customers. Elegantly dressed pedestrians crowd the sidewalk on the left and a luxury automobile is stopped nearby at the curb. This view, though, is countered, but in a subtle way, by elements fully déclassé: for example, the streetcar as "mass" transit and the poolroom and cigar store signs that suggest the merely popular (if not the vulgar) rather than the tasteful. Most postcard publishers oriented their product to gentry proclivities. Postcards necessarily supported booster agendas that saw a city as improved and as improving, following the dictates of society's elite. To that end, downtown Allentown is made to appear safe, clean, and otherwise progressive in the night.

ALLENTOWN, PENNSYLVANIA. HAMILTON STREET, CIRCA 1915.

*P*ostcard images worked to promote selected, attenuated, but highly amplified impressions of city life, including those of the night. Postcards denoted in that they offered images of things variously located in specific urban places, but they also were connotative in that they helped sustain beliefs and attitudes about cities generally. Postcard publishers relied on a standard set of compositional devices in picturing cities. Here, in the section known as "Five Points" where five streets merge, is the heart of Atlanta's downtown, a traditional urban landscape oriented to a grid of streets, each street closely lined by buildings whose facades, block by block, seem to coalesce as an edging "wall." Employed in this postcard is an elevated "bird's-eye view," the scene thus enhanced over what a pedestrian might have experienced at street-level. Sight is channeled along two streets that together offer complementary vistas, drawing the viewer's eye from foreground to middle ground to background. The view suggests that big cities, such as Atlanta, were complex (and, perhaps, even taunting in their complexity) and yet at the same time infinitely knowable through the simplifications of postcard art.

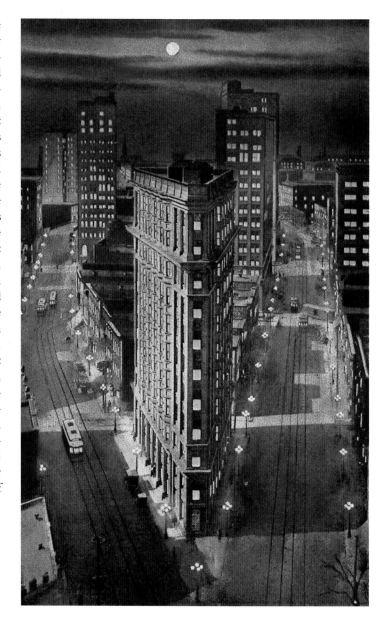

ATLANTA, GEORGIA. "FIVE POINTS," CIRCA 1920.

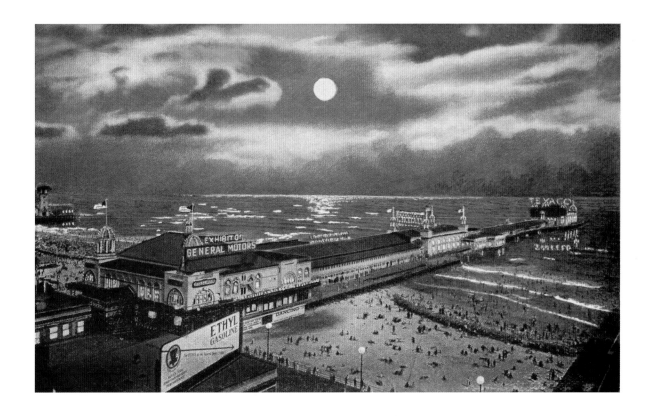

It was the tourist's gaze, perhaps more than any other, that postcard publishers sought to excite through city views. The tourist's conception of place tended to the aesthetic, visual novelty rather than to everyday utility looming large. The tourist's take on landscape and place was essentially the outsider's view, with judgment based more on appearances than on actual experiences. Cities were prime tourist attractions even where, as in Atlantic City, communing with "nature" provided the rationale for visiting. One went to the beach to enjoy healthy sunshine and fresh sea breezes certainly; but visitors to this, and to most other seaside locales, turned their backs on the sea and faced fully the town, especially at night. Along the Atlantic City Boardwalk, and along the many piers thrust out into the water, were penny arcades, ballrooms, restaurants, and other entertainment venues brightly lit in carnival fashion. As elsewhere where crowds gathered, huge electric signs and floodlit billboards advertised gasoline, automobiles, and all the other goods and services of an increasingly materialistic, consumption-oriented urban society.

ATLANTIC CITY, NEW JERSEY. THE STEEL PIER, CIRCA 1925.

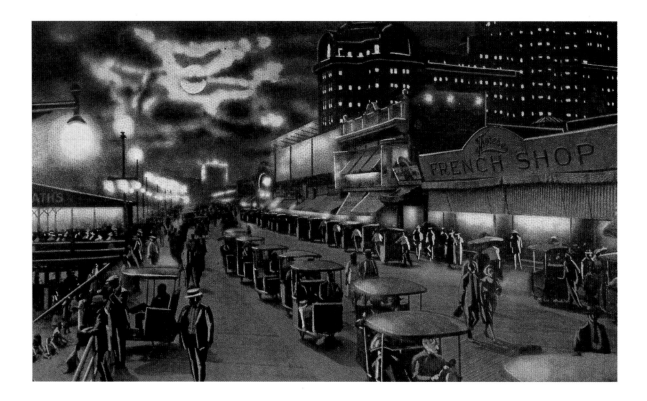

Here is the pedestrian's view of Atlantic City's Boardwalk, with railings and streetlights on the left and building facades on the right appearing to recede into the distance. So also do several lines of "rolling chairs" direct the eye forward. The use of a wide-angle lens enhances a sense of depth in that details at the margins of the view are "gathered" and oriented toward an implied vanishing point well within the photo's frame. Light—both moonlight and that of artificial illumination—is depicted as balanced around that point. As constructed, the view is very much in the perspectivist tradition: single-point or Cartesian perspective so familiar and so transparently evident in the visual arts that most Americans accepted it as the natural basis for observation. The rolling chairs (what the card's caption tells us the card is really all about) carry profound social implication. They offered an opportunity for ordinary Americans to be pampered in emulation of the privileged classes, doted over by a kind of servant, a chauffeur engaged to pedal them about the Boardwalk for a small fee.

ATLANTIC CITY, NEW JERSEY. THE BOARDWALK, CIRCA 1925.

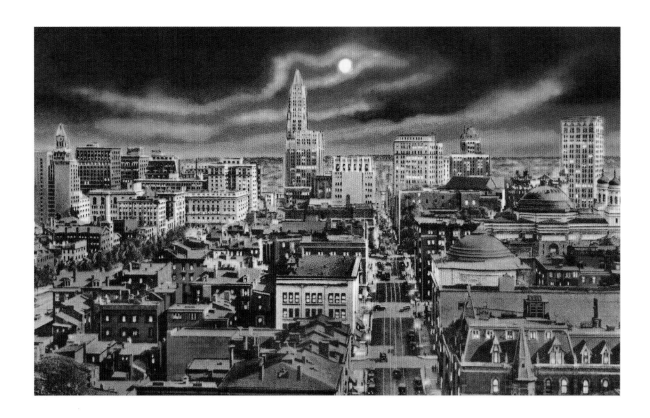

Only in America did tall buildings pile up to great heights to form exaggerated city skylines, at least through the 1950s. New York City and Chicago led the way, but no urban center of any pretense was without its skyline-defining towers, most built as corporate symbols. A skyline stood, as well, as a ready city symbol, its parts summing as civic gesture. In nighttime postcard views, skyscraper windows were made to emit bright light, with building facades also pictured as bathed in moonlight or as brightly floodlit. Offered here is a panoramic scene, the eye allowed to survey out and across a city toward its distant downtown. Leading the eye into the picture is a brightly illuminated city street offering a more confined sense of vista. A vista is a view variously restricted by conspicuous bounding margins so the viewer's sight is directed or channeled forward. Invited is exploration ahead and, by implication, movement forward. Here Baltimore appears in outline only as dark shadow cloaks much from view. A bright moon gleams overhead in a romantic counterpoint to the skyline's modernism. (Postcard courtesy Lake County [IL] Museum, Curt Teich Postcard Archives.)

BALTIMORE, MARYLAND. CITY SKYLINE, 1934.

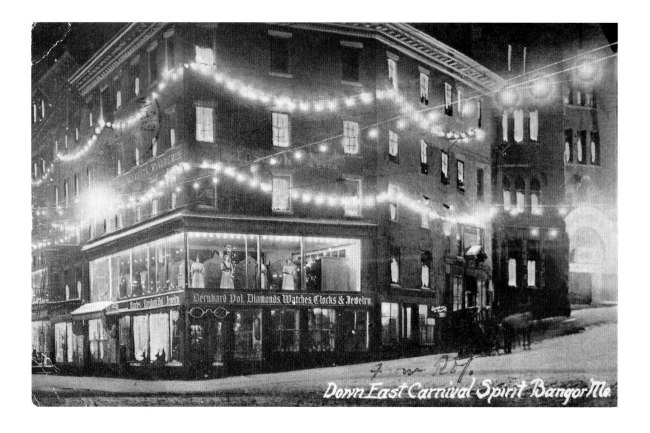

Down East Carnival Spirit Bangor Me.

In the traditional downtown, buildings were to be noticed and remembered in passing and, as needs arose, entered directly from the public way. As such, they stood as distinctive places. At night, lighting inside could open a store's interior to outside view, its window glass, opaque when seen from any distance in daylight, made fully transparent. Here was a clear invitation to the postcard photographer to explore visually the intersection of public outside space and private inside space. Building interiors, when brought into view, made streets appear more intimate and more inviting to potential use. In this scene, seasonal street decoration adds humanizing effect, with the street brought alive through festive electric light despite a lack of people. Night light was not only facilitating in a strictly utilitarian sense but also was conducive to a sense of celebration.

BANGOR, MAINE. DOWNTOWN STOREFRONT, CIRCA 1910.

With automobiles more and more numerous, street lighting came to dominate nighttime urban landscape. Traffic engineers sought to light traffic ways not only uniformly but eventually at levels of brightness approaching that of daylight. In Birmingham, as in other cities, downtown streets after World War II came to shine as "canyons" of bright light. If at night the motorcar did not sit at the curb, engine running and impatiently ready to go, then it was racing down a street, its path intensely lit. Generally overwhelmed were the celebratory and even the informative uses of artificial illumination, including festive lighting and illuminated signs and display windows. The brilliantly lit nighttime street was rationalized as a traffic artery. As such, it fit the modernist's penchant for things brighter and bigger—and faster— as always inherently better. Substantially lost in cities after dark was pretense to the romantic and, as well, to the picturesque through the play of dark shadow.

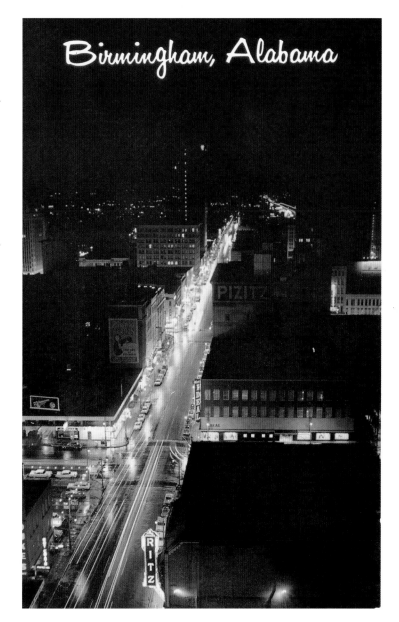

BIRMINGHAM, ALABAMA. SECOND STREET, CIRCA 1960.

*H*ere modern skyscrapers are seen towering above a parking lot, the whole set off, for visual effect, against an enhanced orange twilight sky. Thus represented is a new kind of city (and a new kind of urbanism) formed not around the movement of pedestrians but around the movement of motorists cocooned in cars. In the new city, buildings no longer crowded the margins of city streets but sat back and away at some distance, often isolated in parking lot surrounds. Gravity-defying towers, conjoined with shadow-busting street lighting, spoke forcefully, indeed, of progress through engineering.

BOSTON, MASSACHUSETTS. PRUDENTIAL CENTER, 1970.

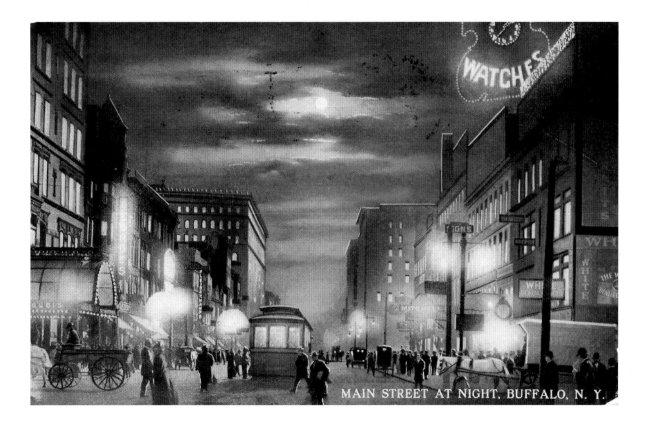

In the abstract, urban built environment is comprised visually of patterned relationships, such as those of height to breadth, solid to void, color to color. It was the photographer's challenge to discover and render those patterns imaginatively in picturing a city, fusing the visible into coherent compositions thus to replace mere vision with visuality. As a consequence, widely adopted formulas entered in. Downtown Buffalo, as pictured here, stands as a fusion not only of light and dark but of objects large and small depicted both as fixed and as moving: a gestalt of active street life clearly preautomobile. No motor vehicles are present, and pedestrians swarm both the street and its sidewalks. For the first half of the twentieth century, the importance of the traditional street as visual organizer—as sustainer of street vistas most especially—cannot be overemphasized. With ease did postcard photographers position their cameras at street-level, the view obtained very much what pedestrians saw. Buildings along a street, when pictured at an oblique angle, stood less as "architecture" to visually congeal more as "landscape."

BUFFALO, NEW YORK. MAIN STREET, CIRCA 1905.

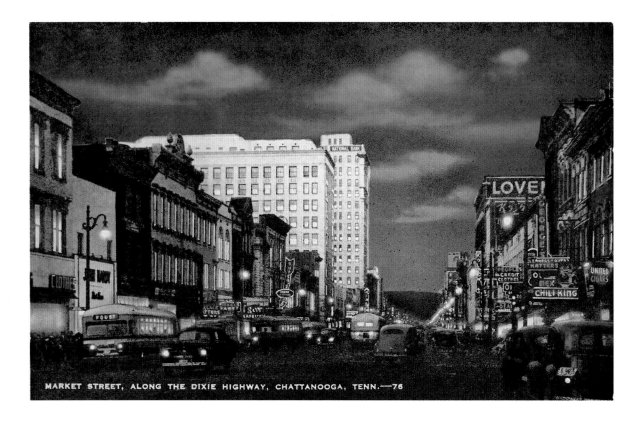

MARKET STREET, ALONG THE DIXIE HIGHWAY, CHATTANOOGA, TENN.—76

*L*it electric signs served to enliven traditional storefronts at night. When projected out over sidewalks, they could readily attract the eyes of passing motorists as well as pedestrians. After 1930, signs outlined and lettered in neon or backlit with fluorescent tubes became increasingly brighter in order to counter increasingly stronger street lighting, a cause all but lost after 1950 with the widespread adoption of mercury-vapor and sodium-vapor streetlamps. In this view of Chattanooga, a floodlit bank building serves as a strong focal point, fully anchoring the scene by making the street appear partially closed off from the left. By pointing the camera's lens slightly upward, the photographer has caused the viewer's gaze to appear somewhat constricted in the distance, enhancing visually the street as a contained space.

CHATTANOOGA, TENNESSEE. MARKET STREET, CIRCA 1950.

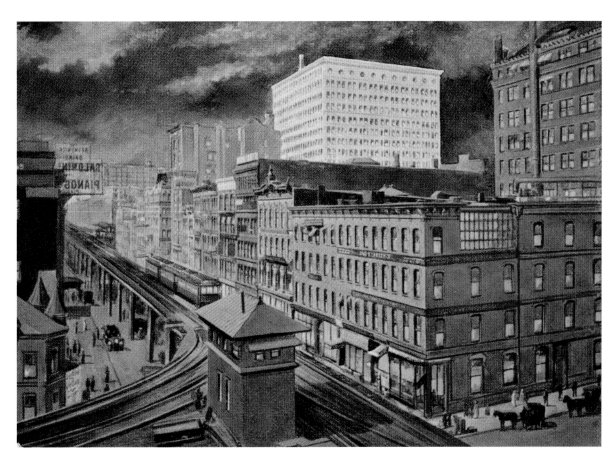

Most building facades were designed for their daytime look when architectural details stood out boldly. In the dark of night, however, ornamentation often disappeared from view. Light, as with floodlighting, could be used to replicate a building's daytime aspect or it could be used as an architectural modifier, creating (through projected shadow as well as light) a distinctive nighttime look. Through dubbing and touch-up work the same visual effects could be created in postcard views. Here a deflected vista has been contrived by the photographer, with the viewer's eye encouraged across the grid of Chicago's downtown streets and sent, at an angle, up Wabash Avenue, the building facades receding with distance. The curving track of the elevated railroad carries the eye forcefully around the curve and along the axis of the street. Only then is the eye free to survey taller buildings pictured as floodlit beyond, especially the Railway Exchange Building with its brightly gleaming terra-cotta made into a convenient focal point.

CHICAGO, ILLINOIS. WABASH AVENUE, CIRCA 1910.

Streets had dual functions. As public ways they did serve as traffic arteries in connecting city space. However, they also provided context for architectural enclosure. Thus, in the traditional city it was along streets that buildings were arrayed to be seen and from which they were to be accessed in use; in other words, buildings, as places, were standing as potential destinations. "Prospect," the ability to see unimpeded, was emphasized in postcard views through the clear depicting of vista, particularly the vista of the street articulated as an implied axis for movement. Important also was the picturing of "refuge," locales where one might safely step aside in avoiding the commotion of the street. In the nighttime city, and in nighttime depictions of cities, refuge was implied in illuminated building facades and especially in lit building entrances where inside space and outside space could be seen as conjoined. The size of a building's entrance usually reflected the size of the interior space immediately to be entered as well as the scale of activity contained therein. Emphasized here are the exaggerated entrances of Chicago's principal department stores.

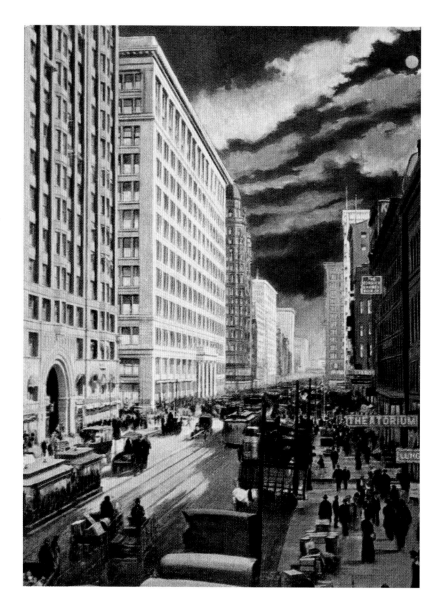

CHICAGO, ILLINOIS. STATE STREET, CIRCA 1920.

*A*ctivity in the modern city relied on collective mental constructs substantially rooted in visualization: conceptualizations as to how a city's geography broke down into parts and, conversely, how those parts congealed. Here is a view north from the Chicago River along the axis of Chicago's new retail boulevard, what came to be called the "Magnificent Mile." This card's caption orients the viewer to key landmarks: "On the right is the Tribune Tower, Medinah Athletic Club, Allerton Hotel and the Palmolive Building. At the left in the foreground is the Wrigley Building." Aerial views of cities from airplanes became increasingly popular as aviation matured. Landscape became a visual surface to be flown over as well as a visual surround to be moved through. In postcard art, the tall building with a beacon became a nighttime affectation. Beacons linked air travel symbolically, if not functionally, with elements of urban landscape traditionally experienced on the ground. (Postcard courtesy Lake County [IL] Museum, Curt Teich Postcard Archives.)

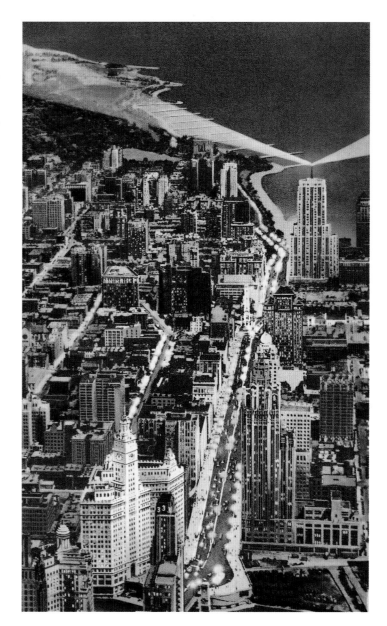

CHICAGO, ILLINOIS. NORTH MICHIGAN AVENUE, 1938.

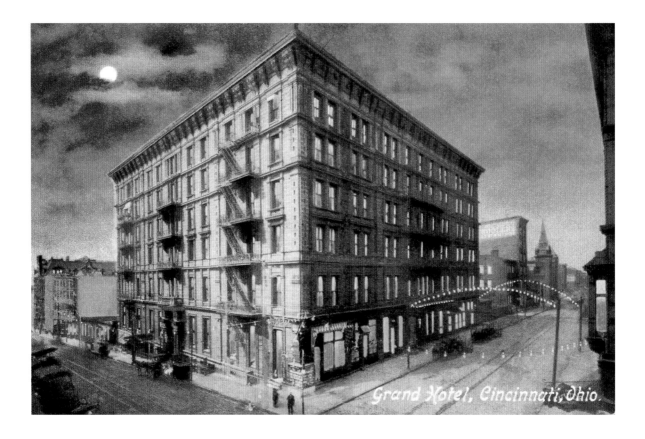

If nighttime landscapes were first conceptualized in the broad outlines of "prospect," especially in terms of vista, then they were next read for the place implications of "refuge." Appraising the night for place meaning involved interpreting what light specifically disclosed.

Light not only differentiated one place from another as setting or locale for behavior but showed how each place was to be approached and entered. Here a hotel entrance is announced: bright light depicted as emitted through a doorway and adjacent windows. A festoon of electric bulbs arches across the adjacent street to complement the hotel entrance. Moonlight, depicted as reflected on one facade of the hotel, amplifies the building's silhouette. The hotel is made fully legible as a distinctive place, thus with a full invitation to enter.

CINCINNATI, OHIO. THE GRAND HOTEL, CIRCA 1905.

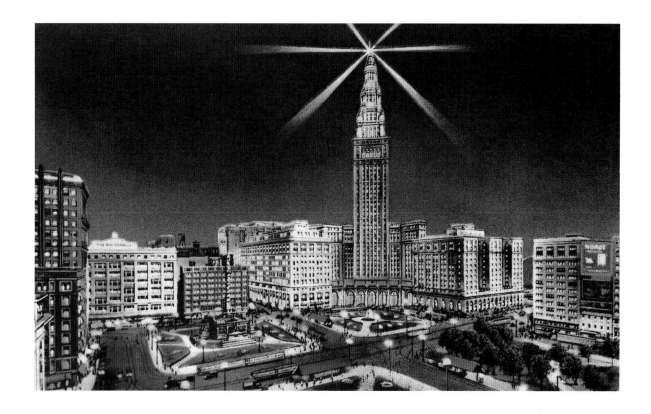

Public plazas were more difficult to photograph as opposed to single buildings and streets. Viewpoints were less obvious, and effective composition required greater effort. Buildings stood as solids, things with structural integrity, and could be pictured as objects. Traditional streets offered prospect along well-defined vistas fully outlined by adjacent facades. The open square, conversely, was essentially a void, an emptiness. Visual character was defined by its peripheral surround and also by a central anchor, if any. The view from within was not forward and along but fully around and about, something that required swiveling the head and something that the ordinary camera lens could not replicate. In this view, Cleveland's Public Square—actually four squares clustered around a dividing intersection of streets—is depicted surrounded by a relatively low wall of buildings, the ensemble dominated at one corner by a massive skyscraper, the Union Terminal Tower. It is actually the tower that is celebrated. Public plazas were relatively few in American cities since most cities were laid out in strict street grids characterized by monotonous repetition of right-angled intersections. Interruption of a street grid by a public ceremonial space, however, represented an important opportunity for postcard photography despite the compositional difficulties. (Postcard courtesy Lake County [IL] Museum, Curt Teich Postcard Archives.)

CLEVELAND, OHIO. THE PUBLIC SQUARE, 1936.

Cleveland's Public Square was, perhaps, too large. Viewed from within, its surrounding edges, lined primarily by low-rise buildings, appeared weak given the square's very broad extent. The plaza's central intersection negated opportunity for a single strong focus. Only in one quadrant of the plaza was there even a hint of centrality: the Soldiers' and Sailors' Monument. Nonetheless, the photographer has rendered here a photograph fully suggestive of strong center-periphery relationship, constructing the scene by using the monument and the nearby Terminal Tower as visual foils. Weak landscape configuration did not stop postcard photographers from contriving city views otherwise suggestive. It was a publisher's intent, of course, to celebrate a city and not demean it since publishers generally were seeking to portray cities at their impressive best.

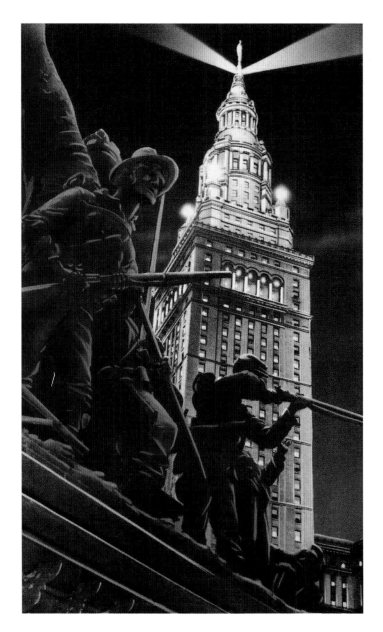

CLEVELAND, OHIO. TERMINAL TOWER, CIRCA 1930.

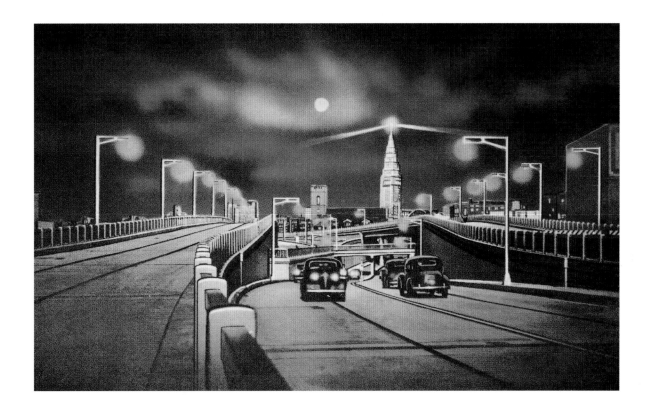

The mode of travel through a city influenced what was seen as well as what was remembered—but few postcard publishers before 1960 explored the motorist's view of the city, a view implied in this scene. "The approach and underpass . . . shown here [speeds] the safe movement of traffic to Cleveland's east side and downtown district," this card's caption reads. It continues: "Latest improvements to safeguard motorists have been installed including a new 'Sodium Lighting System,' which emits a non-glare light." Early sodium-vapor lamps created what was thought to be an "unnatural" yellow light. They were seen to "discolor" since faces and clothing appeared to turn brown. Accordingly, they were not used to illuminate city streets and plazas frequented by pedestrians. Instead, they were restricted to illuminating highways, their unusually bright luminance, which seemed to preclude dark shadow, considered enhancing to nighttime traffic safety. (Postcard courtesy Lake County [IL] Museum. Curt Teich Postcard Archives.)

CLEVELAND, OHIO. WEST APPROACH TO THE MAIN AVENUE BRIDGE, CIRCA 1940.

Postcard views tended to ignore, and even omit through photo retouching, much visual detail. Through omission, street scenes like this one could be made to appear uncluttered and orderly (thus more progressive and more modern) than visual reality might warrant. Omitted here are the streetcar tracks and overhead trolley wires that spoke not of a modern automobile future but of an antiquated transit past. Added here are straight-edge lines drawn in to reinforce building silhouettes and window surrounds. The South Carolina State Capitol, which terminates the view in the distance, is totally reworked through such dubbing. Of course, postcards could not communicate the details of sound and smell or the kinesthesia of bodily movement, but one was free to imagine such things.

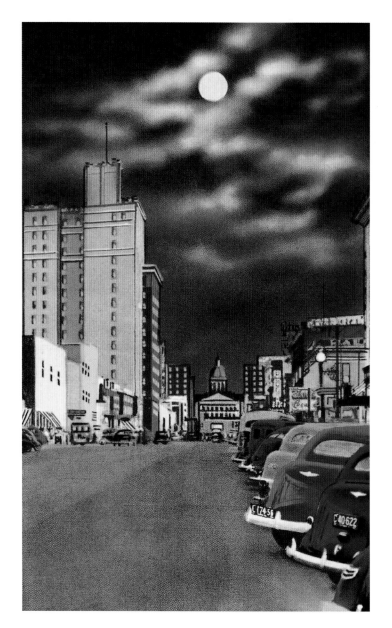

COLUMBIA, SOUTH CAROLINA. MAIN STREET, CIRCA 1940.

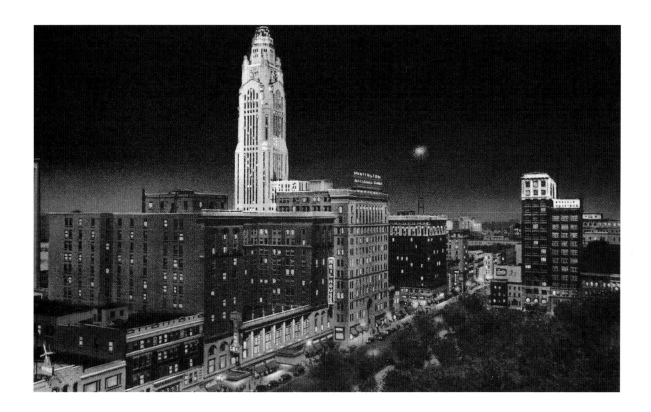

For most viewers, postcards communicated solely as visual messages. Cities, in their depiction, were made out to seem little more than visual displays. Postcards suggested not only what could be seen in cities but how that which was seeable might be visualized. Emphasized, of course, were city streets. Emphasized also were important landmarks, not places through which people regularly moved but places easily noted in passing, that is, highly legible places that stood out in attracting attention. Landmarks cued movement and, accordingly, were useful in conceptualizing city space as geography. Floodlit here is Columbus's LeVeque-Lincoln Tower (long known in the city as simply "The Citadel"). The camera, positioned on a distant rooftop with a wide-angle lens pointed diagonally across the city's grid of downtown streets, produced a picture organized or composed around several implied triangles. Depicted as floodlit with strong figure-ground implication, the tower is made to fully resonate as a nighttime landmark structure. (Postcard courtesy Lake County [IL] Museum, Curt Teich Postcard Archives.)

COLUMBUS, OHIO. BROAD STREET, 1932.

This card is captioned: "Height 400 ft.—29 stories above ground—2 below surface—1800 exterior windows—1400 telephones. . . . The large revolving . . . PEGASUS . . . atop the building measures 40' by 32' and can be seen for many miles at night and guides many motorists to heart of Dallas." Since Americans much relished statistics that told of things on a grand scale, publishers liberally filled postcard captions with numerical superlatives. Americans also liked big things. Shown here, glowing red, is a giant winged-horse that seemed to gallop across the city's night sky. It long remained a Dallas icon, a symbol not only of a national corporation (and the oil industry that it represented) but of the city itself. Everyday experiencing, including the consumption of postcard art, gave rise to shared feelings about cities and recognition of what might be called a city's "sense of place" (or even "spirit of place" or "genius loci"). Such reasoning echoed the Roman conception that every independent being had his or her genius or guardian spirit. It was what gave life to people and to places. The Pegasus, with its allusion to classical mythology, enlivened downtown Dallas after dark. (Postcard courtesy Lake County [IL] Museum, Curt Teich Postcard Archives.)

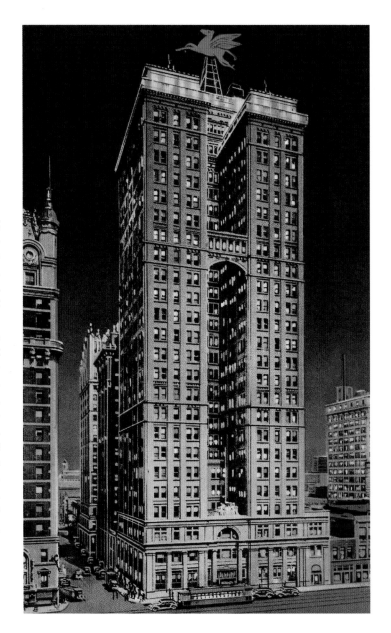

DALLAS, TEXAS. THE MAGNOLIA BUILDING, 1936.

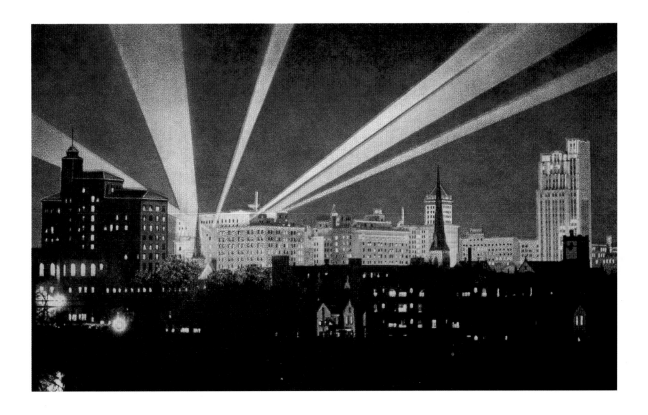

Searchlights shown crisscrossing the night sky could enhance a sense of city spectacle. Such exaggeration, almost always dubbed in, provided postcard publishers with a ready means of improving a picture's composition. "Scintillators," indeed, did send beams of light skyward in Dayton and in other cities, especially during times of city festival. First introduced at the Hudson-Fulton Celebration in New York City in 1909, the technology reached its height of perfection at the large world's fairs held in San Francisco, Chicago, and New York City in the 1930s. The use of searchlights was sufficiently widespread that their fictional depicting in postcards appeared quite plausible. Searchlights might have symbolized Dayton's embrace of aviation since the city was home to Orville and Wilbur Wright as well as to a complex of military airfields under development nearby in the 1920s. In this card's caption, however, a commonplace booster's tale is told: "Merchandising analysts recognize Dayton as one of the outstanding retail markets of the nation. It is the dominant shopping center of the Miami Valley. Thousands of factories produce an annual payroll of nearly $100,000,000. Tobacco, cattle and grain lead the produce."

DAYTON, OHIO. SKYLINE, CIRCA 1925.

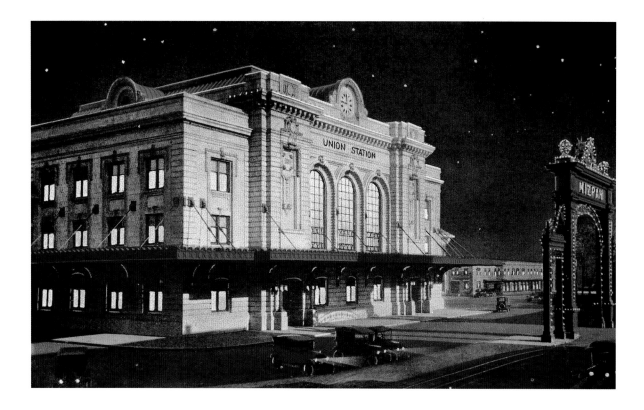

Before World War II, it was the railway station—and not the airport—that greeted travelers arriving in a city. Denver's Union Station was floodlit at night, and out front, as depicted here, stood a welcoming gateway arch. "Tourist travel in the past few years has increased by hundreds of thousands," this card's caption asserts, "much of which passes thru [sic] Denver's Union Station, a most conveniently arranged and located structure. . . . While Denver is the twenty-fifth largest city in the United States, it ranks seventh in the number of passengers arriving and departing by train." Light spoke variously in the night as potential destination, the eye being drawn instinctively to where it could see. On the one hand, that which was illuminated in the dark became, to the gaze, a natural center of interest. On the other hand, that which was only poorly seen in dark shadow was reflexively subordinated. If, unlike moths, Americans were not instinctively drawn to light at night, they were at least guided and reassured by it.

DENVER, COLORADO. UNION STATION, CIRCA 1920.

Bird's-eye views offered a holistic grasp of a city. Here Denver is reduced to its street grid, the summation of its thoroughfares depicted as brightly lit in the night. The complexity of the city is simplified in the most elemental of terms: through stark contrasts of dark and light. The postcard's caption reads: "This is a sight to be remembered. Denver has often been called the City of Lights owing to its wonderful lighting system and anyone viewing the city at night from this point can readily appreciate the reason." Beyond the city lies a very different nighttime geography of contrasting dark rurality. The automobile, so integral to the scene's composition, is, in fact, dubbed in. Enhancement in the darkroom, and at the time of printing, produced postcards that were highly fictional. Yet in order to sell, cards, if not fully truthful, had to assert degrees of truthfulness. What counted was plausibility. Of course, by repeating subject matter and by utilizing a narrow range of compositional devices, postcard art asserted for itself a kind of authoritative truthfulness. What was seen over and over again assumed a kind of authority.

DENVER, COLORADO. VIEW FROM LOOKOUT MOUNTAIN, CIRCA 1915.

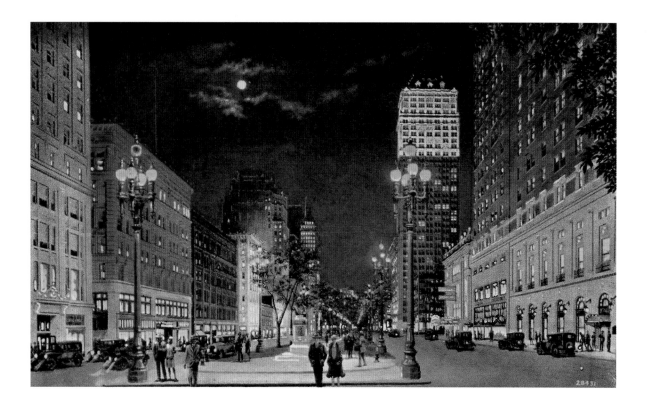

Early in the twentieth century, the downtown was a city's most accessible district. All social classes could be seen on major downtown streets, especially early of an evening in the summer months: well-to-do club men and their wives, up-and-coming shopkeepers and their families, young women headed to or from clerking or office jobs, servant girls and their male escorts, and literally every other kind of human actor whether of a city or just passing through from faraway. It was in the downtown that cities truly demonstrated their importance architecturally. It was there that those unique qualities—those honored things that served best to symbolize—were most densely clustered. It was usually a city's downtown that set it apart and made it stand out from other cities.

Some streets were specially developed to prestigiously stand out. Shown here is Detroit's upscale shopping street with the city's most exclusive hotels. Pedestrians stroll, with the street's parkway landscaped to fully accommodate them as urban spectators. Almost all postcards depicted northern cities in the gentle summer months, part and parcel of showing them at their best.

DETROIT, MICHIGAN. WASHINGTON BOULEVARD, CIRCA 1930.

This skyscraper was carefully flood-lit to accentuate its verticality, an effect fully captured in this, a "phytochrome" produced by the Detroit Publishing Company. The firm sold the finest postcard views perhaps ever mass-marketed in North America. The forty-five-story Book Tower anchored Washington Boulevard, a redeveloped thoroughfare some four blocks long, intended as Detroit's equivalent to Chicago's North Michigan Avenue, the "Magnificent Mile." The onset in the 1930s of the Great Depression nixed plans for a companion tower intended to be the world's tallest. Postcard images sometimes were commissioned by developers in promoting their construction projects. With this card, however, only city celebration was intended. Offered is architectural proof of the Motor City's rapid rise to urban prominence through growth of the automobile industry.

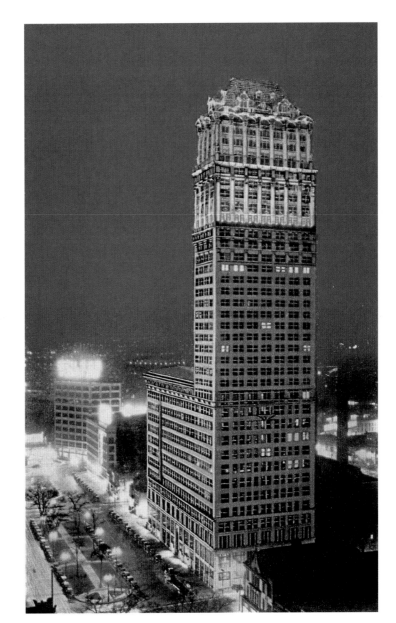

DETROIT, MICHIGAN. THE BOOK TOWER, CIRCA 1925.

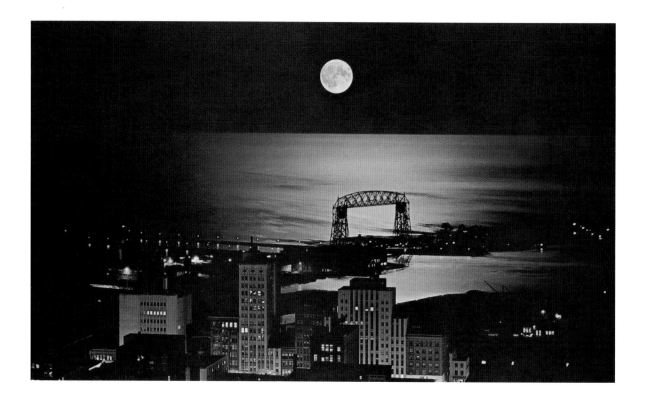

*P*roving that even late-twentieth-century cities could be romantically pictured, here is downtown Duluth, the city's landmark Aerial Lift Bridge silhouetted by a bright moon. With aerial shots, photographers were torn between the technical demands of deep focus and the desire to reveal foreground, to combine, in other words, the visual effects of their telephoto- and wide-angle lenses. Distancing the eye, however, could contribute to the modern look and thus came increasingly to the fore in postcard art. The distanced shot taken from above was especially synthesizing in its effect: modernism's simplifications in the changing city visually amplified. Here, though, the distanced view celebrates the picturesque also, even what Americans, in celebrating nature, once called the "sublime."

DULUTH, MINNESOTA. VIEW OVER DOWNTOWN, CIRCA 1970.

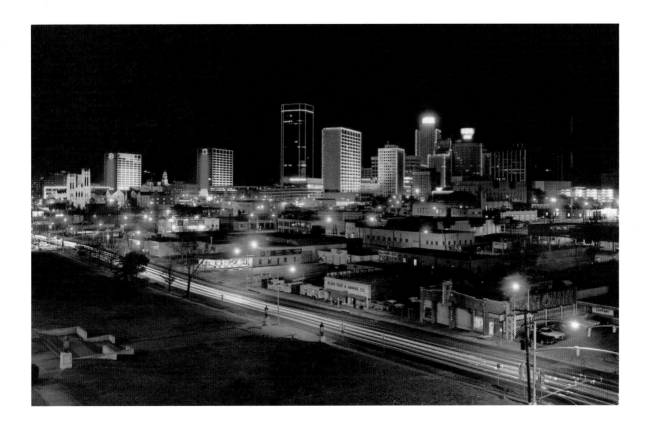

Once curtailed by depression and by war, skyscraper construction was renewed with vigor after 1950. By 1970, the more aggressive cities, particularly in the American West, sported new towers garishly outlined in neon tubing or with exaggerated floodlighting. Fort Worth boosters used night lighting as a means of celebrating "sense of place," especially during the holiday season each year. This card's caption brims with hyperbole: "Fort Worth scores another first. Millions came from miles around to get this view and airplanes were re-routed for the thrill. Few cities are endowed with the cooperation of its citizens to make this scene possible." Admiring night light was one means by which individuals could validate and thus participate in a city's modernism. Beneath the surficial calm, cities were actually chaotic places rife with economic and social change, the drift ever onward toward potentially alienating bigness. Therefore, positive reference points were needed to help integrate society, including a visual lexicon: a palette of symbols from which a city's residents could obtain a proprietary sense of belonging.

FORT WORTH, TEXAS. SKYLINE VIEWED FROM THE WEST EXPRESSWAY, CIRCA 1960.

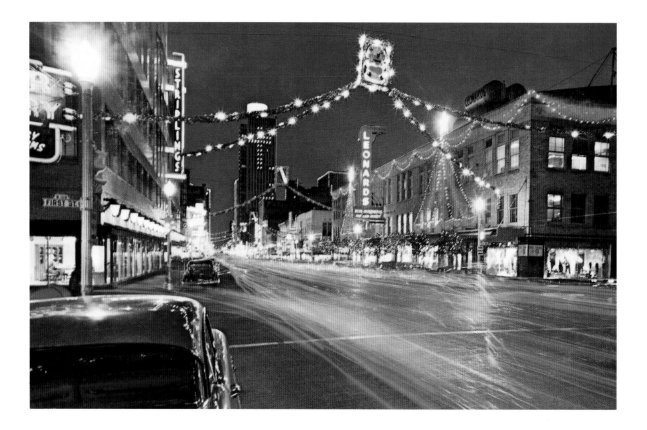

*E*arly on, nighttime postcards catered primarily to pedestrian sensitivities, with the gaze of the walker, as flaneur, emphasized. Increased reliance on the automobile, one might think, would have encouraged views more fully suggestive of what motorists saw. Therefore, more and more the seeing of cities was done out of automobile windshields, the vistas experienced serially in rapid succession. Postcard publishers did depict streets as arteries for speeding cars but did so primarily by employing the viewpoints and compositional devices traditional to the pedestrian-oriented urban night. In this Fort Worth scene, time-lapse photography records blurred streaks of passing headlights and taillights, recognition of the automobile's import. Nighttime auto use came to involve, certainly along the new commercial strips in the suburbs, the exhilaration of fast speed mixed with bright carnival lights, a combination long associated with the roller coasters and other like entertainments of the nation's amusement parks.

FORT WORTH, TEXAS. MAIN STREET, CIRCA 1965.

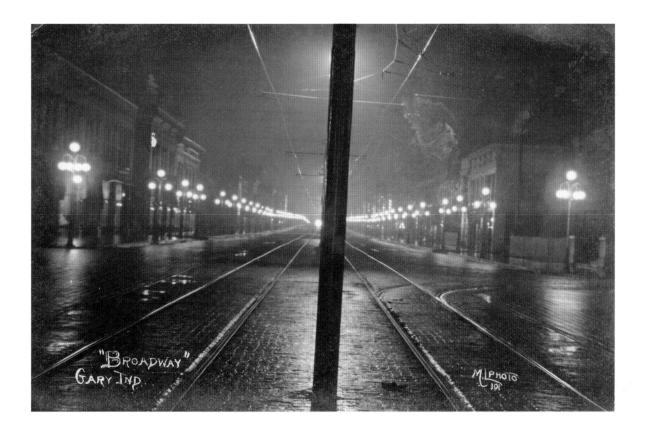

Before fast photographic films, nighttime photography truly challenged photographers. Movement in diminished light was difficult to "freeze," with moving pedestrians and vehicles on darkened streets blurring readily into the depiction. In order to "stop action," photographers at night pictured deserted city streets empty of life. Early films, of course, also were incapable of accurately recording extremes of light and shadow. In this view, features brightly lit dominate fully, with dimly lit background showing only as black shadow and the subtleties of nighttime seeing lost. Here is Gary's principal retail street, an actual photograph printed in a darkroom on postcard-sized paper. The photographer has placed the camera behind a power pole to cut the glare (or halation) from the streetlights, a necessity thereby made to serve art. The eye is carried easily into the photo toward an imagined vanishing point hidden behind the pole. Light reflects on the streetcar tracks as well as on the wires above, reinforcing the sense of pictorial depth. "White way" lighting, comprised of electric incandescent lamps clustered on columns, is arrayed along both sides of the avenue.

GARY, INDIANA. BROADWAY AVENUE, 1910.

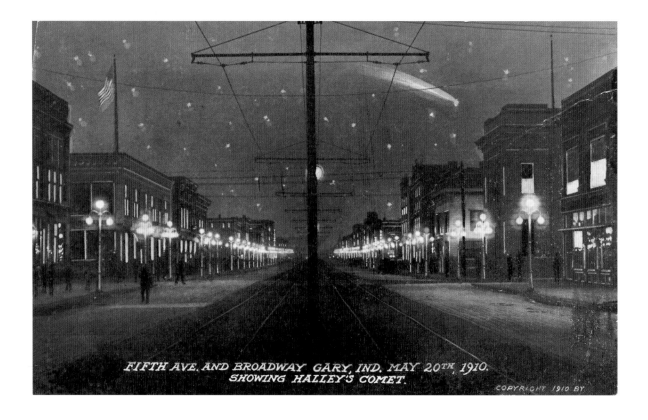

Here is the same nighttime scene taken from the same vantage point but produced from a doctored daytime photo. The street is dark, displaying various intensities of shadow. Streetlights and store windows shine with varying degrees of brightness, a starry field above complete with Halley's Comet. It is a scene highly contrived and, indeed, partly fictional but a scene, nonetheless, that meets the test of plausibility. It was not so much the accurate look of landscape that counted but the strength of suggestion enabling viewers to imagine the night as it was thought to be. In 1910, everyone saw and talked about the comet, a topic fully inviting to postcard depiction. Here it is inserted in the night sky, thus adding distinction to Gary as a place.

GARY, INDIANA. BROADWAY AVENUE, 1910.

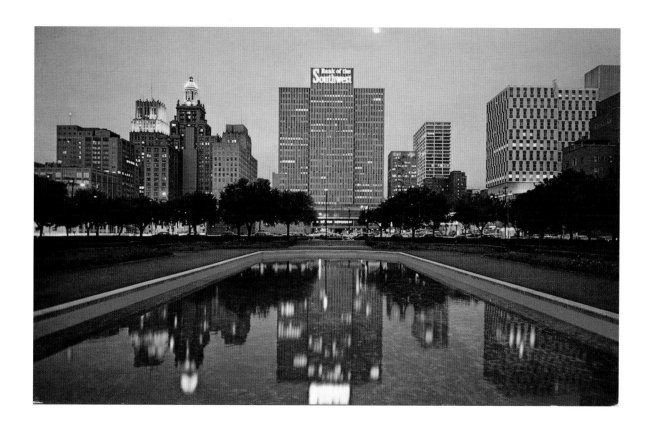

Color photography, in the form of glossy halftone photochromos, came to dominate postcard publishing after World War II, replacing other printed formats. Quick to disappear were cards printed on textured linen paper. Driven in part by the extreme sensitivities of the new color films, photographers developed a preference for twilight rather than night when depicting cities "after dark." Popularized were sunset scenes where colorful skies combined with artificial illumination to enhance visual effect. Although modest retouching was still accepted, highly fictionalized depiction fell from popularity. Perhaps Americans had become too sophisticated in their consumption of visual art to abide exaggeration. America was now awash in imagery, including that of pictorial magazines and motion pictures and, of course, television. The postcards's importance as landscape informant was dramatically reduced.

HOUSTON, TEXAS. VIEW FROM SAM HOUSTON PARK, CIRCA 1960.

The Soldiers' and Sailors' Monument anchored Monument Circle in the heart of Indianapolis's downtown. Most of the plaza's surrounding buildings had concave facades, echoing the plaza's circularity. As in this view, however, the power of the monument far outweighs that of its open surround. For much of the twentieth century, residents and visitors alike referred to Indianapolis as the "Circle City." Having landmark structures was one thing. Having them effectively placed at locations highly visible and having them, at the same time, well integrated visually into a city's overall fabric substantially raised their value as city icon. If Cleveland's Public Square (see page 49) was too large, Monument Circle in Indianapolis was, perhaps, just the right size. (Postcard courtesy Lake County [IL] Museum, Curt Teich Postcard Archives.)

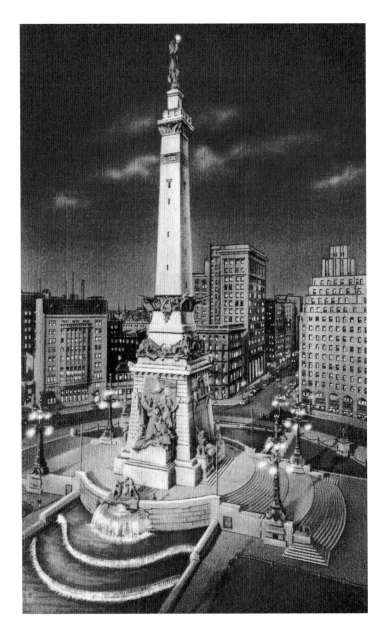

INDIANAPOLIS, INDIANA. MONUMENT CIRCLE, 1933.

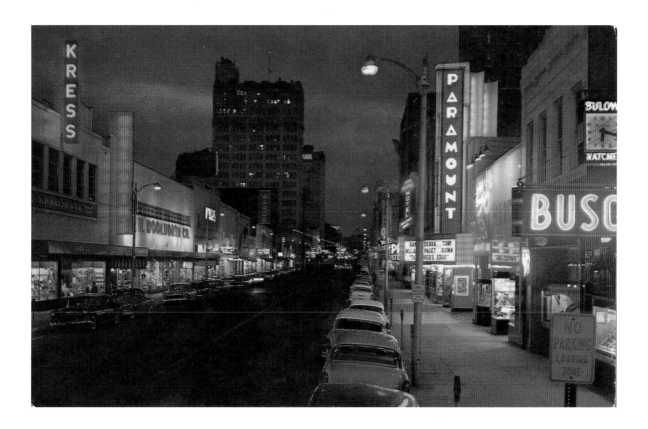

Use of fast color film and reliance on photochromos rather than photomechanically produced prints enabled publishers to market nighttime postcard scenes of subtlety. In this view, store windows are shown lit in an array of light intensities rather than all being gaudily generalized through crude photo retouching. Made more sophisticated was the depiction of place at the scale of the storefront. Here a variety of different advertising signs are clearly differentiated: neon tube, backlit panel, and floodlit billboard signs among them. On the right, a jewelry store's entrance is reinforced by a lit clock, symbolic of the store's merchandise as well as serving as an eye-catcher in marking the door. On the left, two dime store facades carry illuminated signs with readily recognizable brand names symbolic not only of a distinctive line of merchandise but of a distinctive manner of merchandising. Dominating the view is the large sign and marquee of a movie theater. In general, places open and active in the night were necessarily illuminated; places closed were not. Light automatically foregrounded while dark shadow backgrounded.

JACKSON, MISSISSIPPI. CAPITOL STREET, CIRCA 1955.

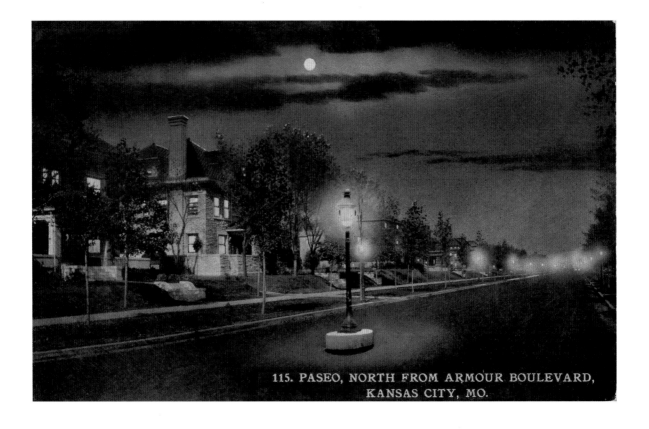

115. PASEO, NORTH FROM ARMOUR BOULEVARD, KANSAS CITY, MO.

*F*or large cities, postcard photogra-phers managed to depict literally every kind of landscape. Nonetheless, in the aggregate, geographical coverage was profoundly uneven. Whole categories of landscape and place tended to be sorely underrepresented, something particularly true of nighttime depiction. To picture well at night — to be photogenic — lights had to shine since scenes largely shrouded in darkness tended to have limited visual appeal. Postcard publishers sold views of residential areas, especially those out along landscaped boulevards and around large parks where a city's more affluent households clustered. Lush vegetation, such as a tree canopy in summer, and a general lack of bright lighting all year round made these sections difficult to depict in nighttime views. They were more readily pictured as daytime scenes. Rarely were a city's slums pictured in postcards or, for that matter, blight or dereliction of any kind. Postcards were instruments of commerce. Their pur-pose was to give purchasers a visual template for celebrating rather than denigrating cities.

KANSAS CITY, MISSOURI. THE PASEO, CIRCA 1910.

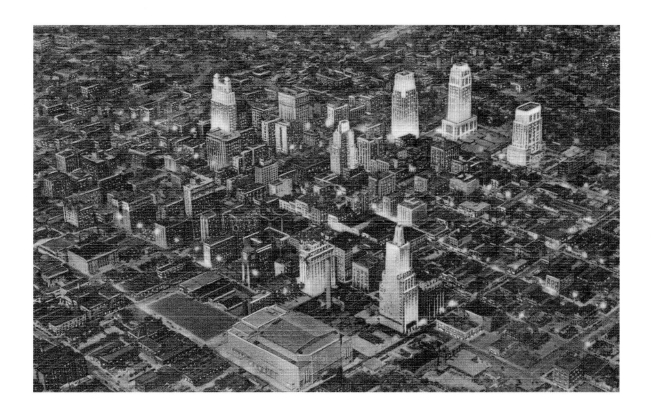

*I*n this aerial view, skyscrapers are out-lined against a darkened background of streets and lesser buildings. It is, of course, pictorial fabrication obtained through exquisite photo retouching. Nonetheless, the final product is fully suggestive of what it portrays. Across the grid of downtown streets, looking much like a giant chessboard, stand skyscraper buildings resembling like giant chess pieces. Was not the American city like a game board where developers, as capital-ists, competed in manipulating urban real estate? (Postcard courtesy Lake County [IL] Museum, Curt Teich Postcard Archives.)

KANSAS CITY, MISSOURI. AERIAL VIEW OF DOWNTOWN, 1941.

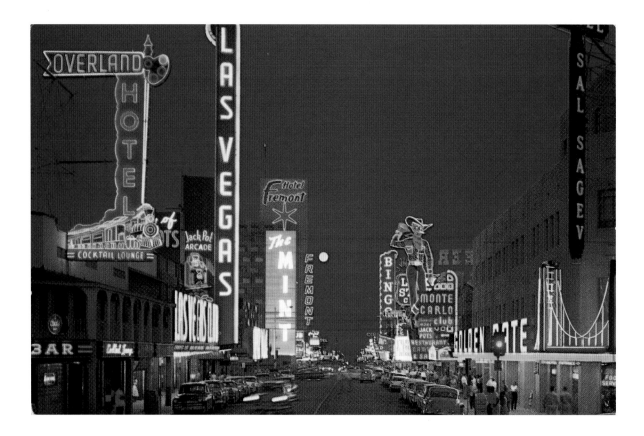

Las Vegas grew from a sleepy railroad town into a major tourist city, with the nighttime glare of large electric signs central to its image. In the bustling downtown, numerous gambling casinos competed for customers through use of exaggerated signs brightly lit. As depicted here, signs soared high above rooftops or consumed entire building facades in a raucous show of pulsating color. In part, Fremont Street followed its own dictates, but its extravagant use of light also met the competition of the city's new, auto-oriented commercial district out along the highway to Los Angeles. There giant casinos were evolving as integrated entertainment complexes, complete with gambling floors, hotels, and nightclubs. Fantasy themes prevailed since Las Vegas, as an entertainment center, was substantially an offshoot of Hollywood. Animated, cartoonlike signs brightened the night in boisterous invitation.

LAS VEGAS, NEVADA. FREMONT STREET, CIRCA 1960.

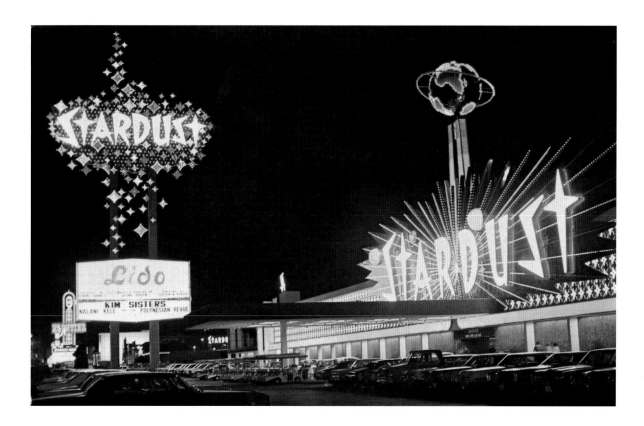

Picturing highway-oriented land-scapes, especially at night, was prob-lematical. The commercial roadside was a spread-out affair difficult to grasp as a visual composite. Buildings were distanced at intervals, and landscapes appeared dom-inated less by objects and more by their separating voids. The American roadside was comprised mainly of low structures set in expanses of driveways and parking lots, the overwhelming horizontality of the whole usually broken only through the verticality of tall curbside signs or signs perched on the buildings themselves. "The Strip" in Las Vegas became the most vividly lit thoroughfare in the United States, even outshining New York City's Times Square as a nighttime spectacle. Repeating at regular intervals along the highway was the sort of visual ensemble shown here at the Stardust: sign, driveway, porte cochere, and parking lot all vividly illuminated. The sign served to attract and cue motorists as to where to turn into the driveway. The porte cochere rein-forced their sense of arrival, telling motorists exactly where to stop their cars. The parking lot further suggested ease of access, making the casino appear fully automobile convenient.

LAS VEGAS, NEVADA. STARDUST HOTEL AND CASINO, CIRCA 1960.

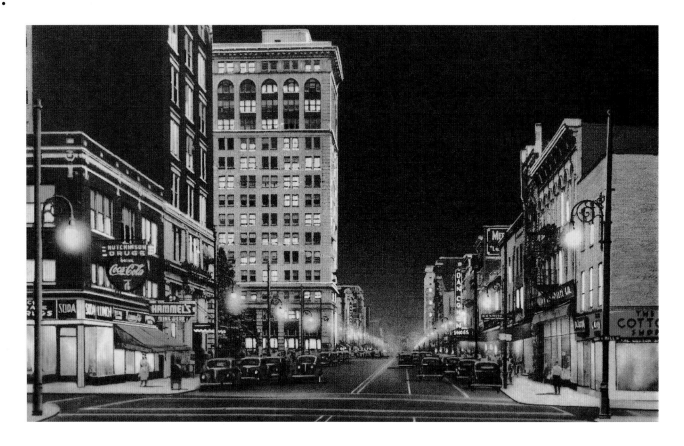

*H*ere is evidence of photo retouch-ing but of a very high quality. Building silhouettes and window and door surrounds, as well as streetlights, are carefully articulated. Reproduced here is a Curt Teich card. Throughout the 1930s and 1940s, Chicago's Curt Teich and Company was the nation's premier post-card publisher, producing exquisite color images on textured linen paper. The company made cards for local distribu-tors, employing scores of salesmen on routes nationwide. Cited as the publisher of this card is the Ferguson News Company, a local news agency. From an array of options, Ferguson News selected potentially salable views intended, as an ensemble, to represent Lexington as an urban place. As a Curt Teich customer, the agency approved all photo retouch-ing and, of course, all card captioning; however, the decisions made were always taken within the relatively narrow con-fines of a distinctly Curt Teich design aesthetic. (Postcard courtesy Lake Coun-ty [IL] Museum, Curt Teich Postcard Archives.)

LEXINGTON, KENTUCKY. MAIN STREET, 1944.

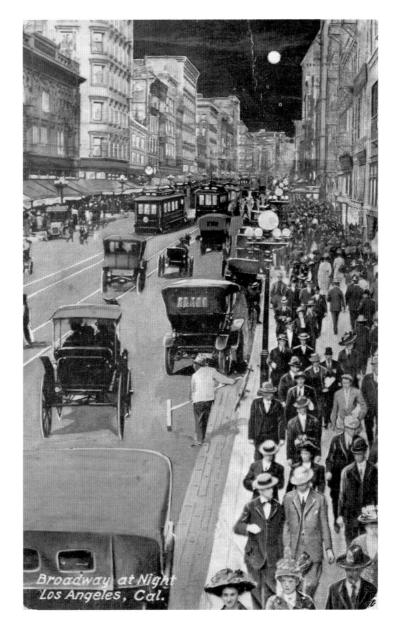

*D*owntown Los Angeles stands very much as a pedestrian place in this postcard view. Streetcars move at center street. Horse-drawn vehicles are visible but more numerous are motorcars. People throng the sidewalks in active street life, the very essence of a cosmopolitan place. Within decades, however, automobile dependence would substantially remake Los Angeles, with traffic congestion downtown diverting customers to shopping centers in outlying localities. When the city's elite retailers relocated to suburban shopping centers, many Broadway stores closed while others reoriented to low-income customers. Downtown sidewalks emptied. By the 1950s, visitors and residents alike began to wonder whether the city had, or had ever had, a real downtown. Here is proof that, indeed, it had.

LOS ANGELES, CALIFORNIA. BROADWAY, CIRCA 1912.

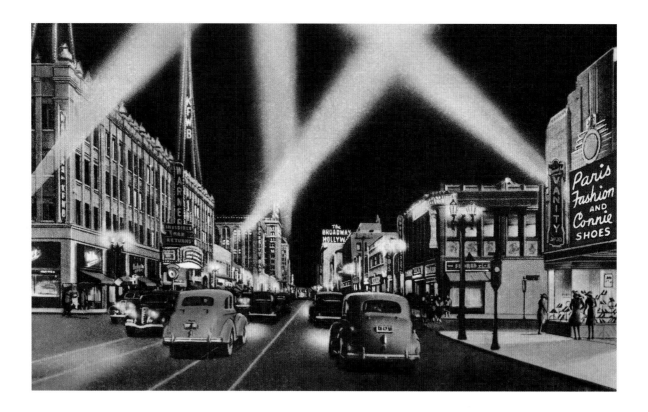

Searchlights greatly enhance the vista of the street in this view. After 1920, searchlights were very much a part of the Los Angeles nighttime scene, contributing substantially to a special sense of place. They not only enlivened the night sky but spoke metaphorically of the motion picture industry centered in Hollywood, searchlight beams being not unlike movie projector beams. This postcard's caption reads: "World famous Hollywood Boulevard . . . is the main thoroughfare of the motion picture capital. Brilliant at night with colorful lights and blazing searchlights, it is a never ending pageant of celebrated characters of Stage, Screen, and Radio." The photographer has placed the camera to the right of the street's center to thus emphasize automobiles moving away from the viewer. This device leads the viewer's eye into the picture with added energy, the street's functional implication as a path for movement greatly amplified. In Los Angeles, perhaps more so than in most cities, people drove their cars to witness night lights, zeroing in, for example, on the sources of overhead searchlight beams—be they advertising a movie premiere or a store opening. (Postcard courtesy Lake County [IL] Museum, Curt Teich Postcard Archives.)

LOS ANGELES, CALIFORNIA. HOLLYWOOD BOULEVARD, 1940.

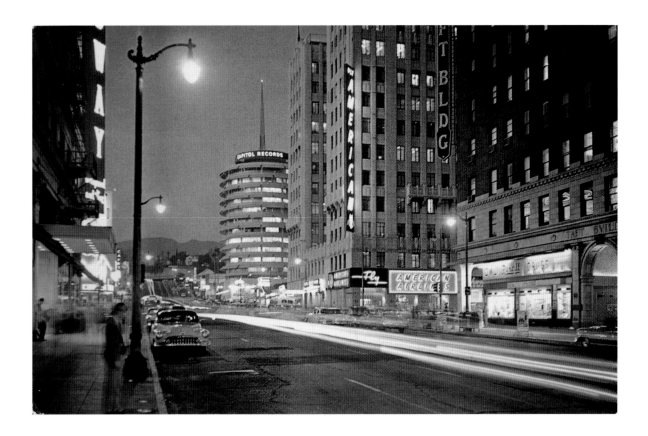

After World War II, intense street lighting visually "congealed" downtown streets as highly homogenized nighttime spaces. America's full embrace of the automobile, with public space becoming largely "machine space," dictated that city streets sustain rapid vehicular movement at all hours. Downtown streets were valued not so much as destinations with vital "street life" as they were valued merely as thoroughfares, arteries for traffic flow. Street lighting reduced the vividness of all other forms of lighting. Lit display windows, floodlit landmarks, and even illuminated advertising signs were overwhelmed. The sense of novelty implicit in nighttime lighting was greatly eclipsed, and, accordingly, the lighting of cities seemed highly predictable and thus commonplace. If a sense of spectacle survived in the nighttime city, it came from the traffic itself. Here the photographer has taken a time-lapse exposure, with the headlights and taillights of passing cars melting into shimmering streams of white and red.

LOS ANGELES, CALIFORNIA. HOLLYWOOD BOULEVARD, 1955.

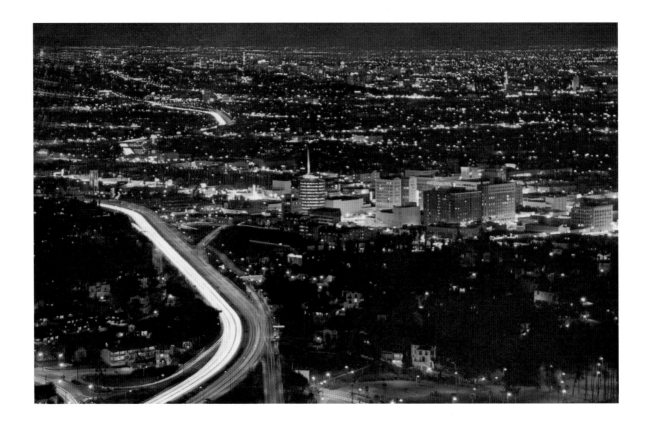

A time-lapse blur of headlights and taillights leads the eye toward Hollywood's business district, its skyline of lit buildings set in strong figure/ground relationship against a darkened background. The array of towers, viewed from across the city at a distance, arrests momentarily the horizontal reach of the surveying eye, the verticality capturing the viewer's imagination. Where the horizontal aspects of a night scene might suggest equilibrium or stability to many viewers, verticality surely suggested release of energy. Towers seem to stand up against the force of gravity, to soar up skyward rather than press down earthward. In night views, the gravity-defying architecture of tall buildings was joined by the night-destroying illuminations of electric light: two modern engineering marvels melded as skyline.

LOS ANGELES, CALIFORNIA. HOLLYWOOD FROM THE WEST HILLS, CIRCA 1965.

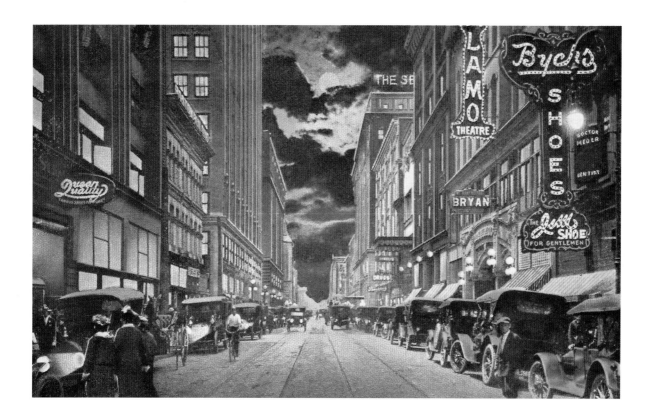

In the vista of the street, architecture was made to coalesce as landscape, to appear integrated along a street's linear array. Most convenient to photographers were shots taken at ground-level, as in this picturing of Louisville's principal shopping thoroughfare. Positioning the camera at the street's center, the photographer composed a picture where pavement, embedded streetcar tracks, building facades, illuminated windows, and lit advertising signs all regressed into the distance. Parked automobiles give the street clear functional implication as a traffic way but also reinforce the street's lateral containment as a visual frame. On narrow streets, the projecting of electric signs outward from storefronts was absolutely necessary to a merchant's catching the motorist's attention. The signs pictured in this view are mostly backlit, with light amplified through glass prisms to spell out words.

LOUISVILLE, KENTUCKY. FOURTH STREET, CIRCA 1920.

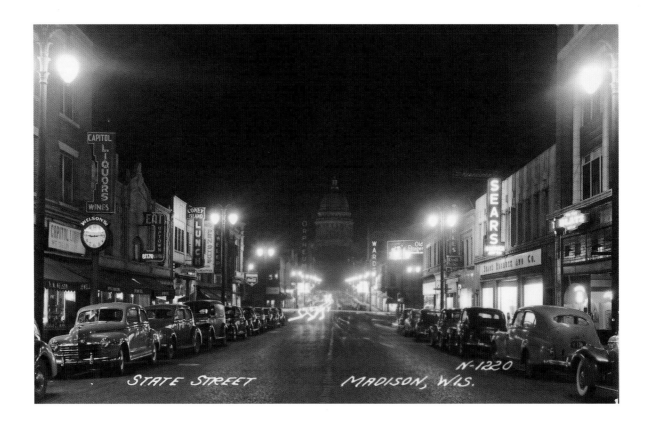

Commercial photographers in cities of modest size often complemented their portraiture and other photo work with an array of postcards sold through local stores. Black-and-white "real photos," as collectors now call them, usually were produced in small batches in studio darkrooms, each postcard an actual photograph printed on postcard-sized photo paper. Little if any retouching was involved, making these views seem highly realistic as landscape depictions, certainly in comparison to colored postcards photomechanically reproduced. Today they carry documentary implication for their apparent truthfulness. Nonetheless, like other postcard imagery, subjectivity entered through the photographer's choice of camera, lens, and film as well as through choice of viewpoint and compositional emphasis. A relatively long exposure has been used here, the car headlights and taillights in the distance slightly blurred accordingly. Streetlights, signs, and store windows are slightly overexposed. Only the light reflected off the parked cars seems true, with the photographer's choice being to emphasize reflected light rather than emitted light.

MADISON, WISCONSIN. STATE STREET, CIRCA 1948.

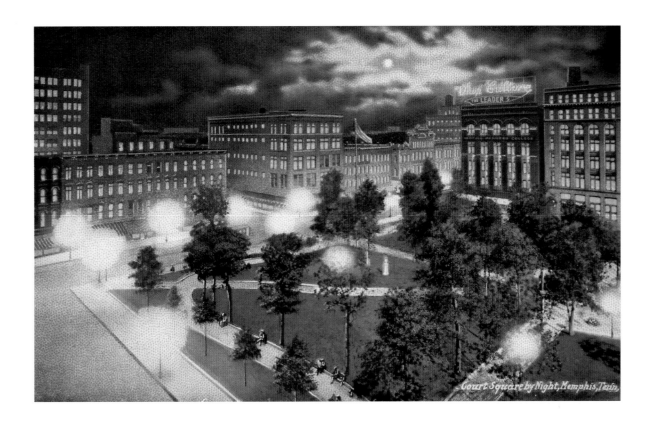

Court Square by Night, Memphis, Tenn.

Public plazas offered a sense of enclosure as the eye was invited to survey a containing surround rather than escape along a linear trajectory. The most effective plazas, at least in a visual sense, were those that had strong central features, their visual energy set to resonating between periphery and center thus making open space appear more effectively contained. Court Square in Memphis is solidly edged by buildings, their windows rather crudely pictured as all brightly lit. The center of the square, in contrast, appears largely empty, substantially a shadowy void. Visual energy communicated from the periphery is thus absorbed and all but lost in its shadows. Pedestrians can be seen to linger on park benches, most likely a pictorial holdover from the daylight photo surely doctored to simulate this nighttime scene. Streets at night tended to be depicted in postcards as bustling with activity. Public squares, though, frequently were depicted as quiet and therefore at least partially outside the city's swirl.

MEMPHIS, TENNESSEE. COURT SQUARE, CIRCA 1920.

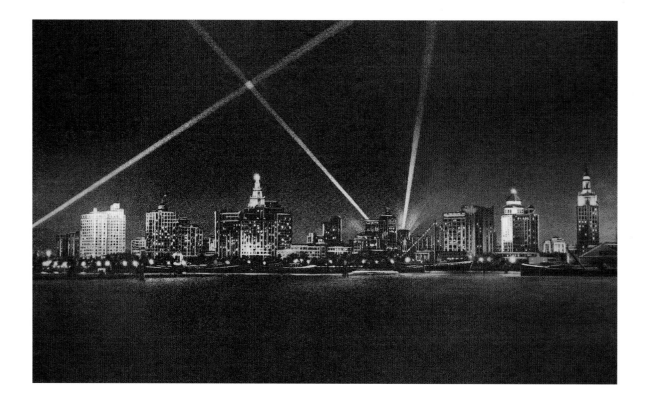

For tourists, Florida was primarily a winter sunshine place; thus, the picturing of the state in postcards seemingly required sunshine, at least judging from the general lack of nighttime views extant today. Unlike New York City, Chicago, and Cleveland (and even Los Angeles in sunny California), early-twentieth-century nighttime views of Miami are scarce. Nighttime picturing of place varied substantially from city to city, with nighttime views figuring prominently in the iconography of some cities fully and of other cities hardly at all. Where emphasized, there was usually a stronger than usual public relations push on the part of a local electric utility involving, among other initiatives, vigorous promotion of electric signs for nighttime advertising. Still, publisher predilection for nighttime aesthetics probably explained nighttime postcard emphasis more than anything else. As depicted here, searchlights work their magic, enhancing Miami's nighttime skyline in strong figure/ground contrast. (Postcard courtesy Lake County [IL] Museum, Curt Teich Postcard Archives.)

MIAMI, FLORIDA. DOWNTOWN SKYLINE, 1932.

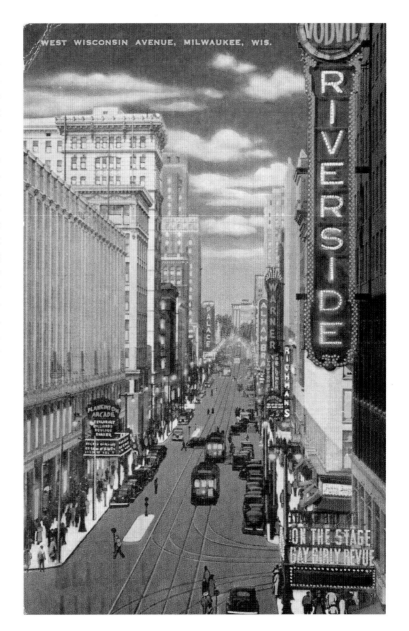

Here is the city's principal downtown street where its major hotels, department stores, and theaters concentrated. The camera is elevated to lengthen the view out and away. Indeed, the postcard is captioned to emphasize what lies at a distance, the street treated not as a destination so much as a thoroughfare: "From the Lincoln Memorial Bridge near the Lakefront, Wisconsin Avenue extends westward through downtown Milwaukee, over the massive viaduct and finally to the beautiful residential district [beyond], a distance of more than six miles." Was it "being there" or "getting there" that Milwaukee's embrace of the automobile encouraged? In the picture itself, few cars can be seen. Indeed, streetcars dominate. This may be a dated photo given extended life through attachment of a new and more timely caption.

MILWAUKEE, WISCONSIN. WISCONSIN AVENUE, CIRCA 1934.

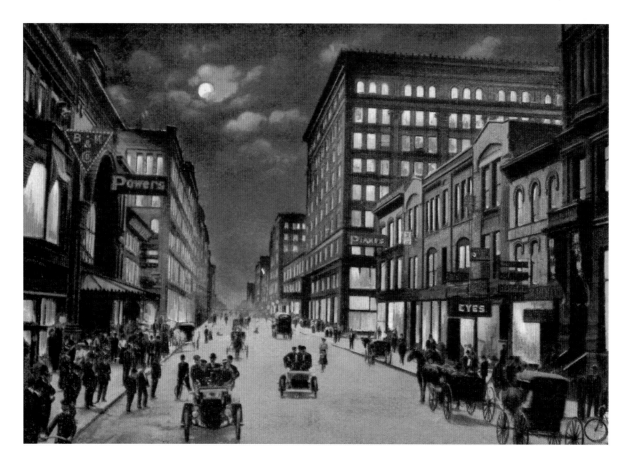

In the early years of postcard publishing, doctored nighttime scenes were often very crude. Here windows in buildings have been given uniform treatment with little subtlety. Automobiles have been added to thus turn what was certainly a dated photograph, perhaps from before 1900, into an image of modern, up-to-date pretense. The street has been cleansed of power poles, streetcar tracks, and even streetlight standards. A fabricated stereotypic moon shines overhead as a cliché. Nonetheless, the image has charm today, if only for its naïveté. It implies a playfulness, a code through which postcard publishers and their customers mutually agreed to pretend. It is not really a past Minneapolis pictured but a future-oriented Minneapolis of the past, a utopianlike vision that both residents and tourists early in the twentieth century would have liked to have seen and would have had others believe they had seen.

MINNEAPOLIS, MINNESOTA. NICOLLET AVENUE, CIRCA 1905.

Postcard publishers, besides marketing general view cards through local agents in drugstores, dime stores, and other businesses, also solicited commercial customers by providing them with advertising cards for distribution. Here one of Nashville's hotels is promoted. The building is depicted floodlit, especially at the street level, where its main entrance is clearly emphasized. Set aglow are numerous large windows that correspond to dining rooms, ballrooms, and other public areas inside. Pedestrians and motorcars are shown juxtaposed, implying ease of accessibility. The place stands in the night as an attractive refuge for weary travelers. Guest room windows on upper floors are shown as brightly lit, further suggesting that, indeed, the Andrew Jackson Hotel is a popular haven. There is an aura of excitement in the building's gleam that announces the establishment as an important downtown landmark, if not destination. This card's caption reads cryptically: "Andrew Jackson Hotel, Nashville, Tenn., 400 Rooms–400 Baths."

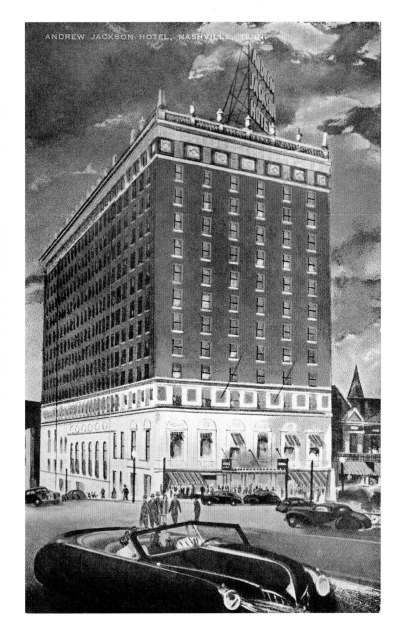

NASHVILLE, TENNESSEE. THE ANDREW JACKSON HOTEL, CIRCA 1940.

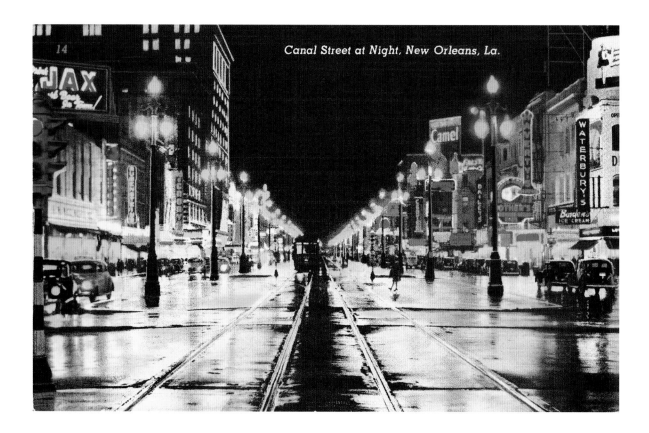

Canal Street at Night, New Orleans, La.

Here is a study in pictorial mirror-effect, a scene that turns in on itself through visual reduplication. Pavement glistening in the rain reflects as it refracts light, thus amplifying a sense of nighttime spectacle. A pair of streetcar tracks and twinned rows of streetlights carry the eye forward. The scene is further organized with strong marginal edges: lit storefronts reinforced by lit electric signs gleaming in the dark as nighttime opportunity. The eye is invited to search for place meaning. What kinds of stores are these? Are they open or closed? Early on, postcard publishers liked to portray streets with every window at every level on every building as fully lit. Concern was not to differentiate place articulated at the scale of the storefront so much as to fully reinforce landscape as street vista. This card is photomechanically reproduced, but the image is very likely from an actual nighttime color negative. It anticipates the postcard publisher's preference for photochromos.

NEW ORLEANS, LOUISIANA. CANAL STREET, CIRCA 1940.

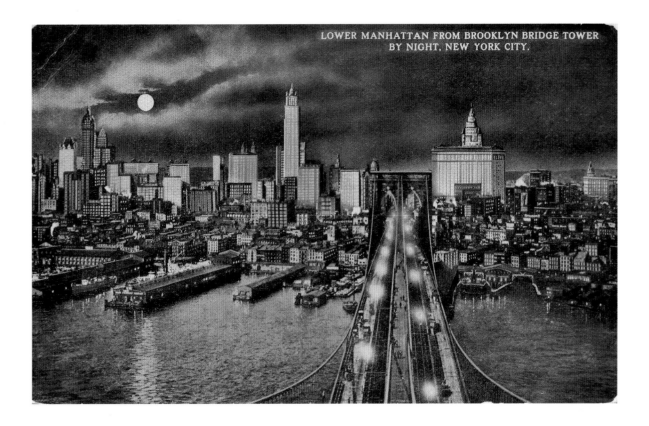

LOWER MANHATTAN FROM BROOKLYN BRIDGE TOWER BY NIGHT, NEW YORK CITY.

*T*he skyscraper was distinctly an American architectural form, their clustering in big city skylines symboliz- ing not only local prosperity but national vitality. Lit at night, skylines were visually "sublime," not defined by awe-inspiring nature but by human genius seemingly in control of nature through modern engi- neering. No skyline topped New York City's in height and in mass. In this view, tall buildings seem to loom up out of the East River like a massive glittering wall, the city thus condensed into a manageable visual entity. Manhattan, in other words, is rendered holistic in a single but power- fully impressive glance. The Brooklyn Bridge, from which the photograph is taken, serves as a gateway, leaving little doubt as to how the city is to be approached and entered. East River piers, in contrast, appear to reach out as if to "gather in." Implied is a landscape of easy access, the city depicted not just as visually exciting but as functionally approachable.

NEW YORK CITY, NEW YORK. VIEW OF MANHATTAN FROM THE BROOKLYN BRIDGE TOWER, CIRCA 1910.

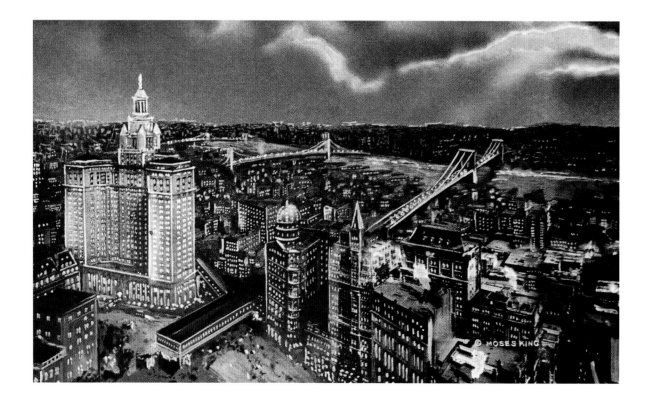

Here is the previous view essentially looking the other way. For tourists, postcards served brilliantly as souvenirs, reminders of places visited. For residents, postcards offered ready testament to their locality's significance. View cards enabled a kind of place consumption. This postcard's caption reads: "From the Woolworth Tower one can get an excellent view to the east. . . . The illuminated bridges connecting Manhattan with Long Island show distinctly. The Municipal Building looms up large in the foreground, while the rest of the city looks insignificant seen from this height, and one can see myriads of lights, throwing their reflection on the water." Taking in the view from atop the Woolworth Tower, especially at night, remained for decades a "must see" experience for all Americans.

NEW YORK CITY, NEW YORK. VIEW TOWARD BROOKLYN, CIRCA 1910.

At first thought appalling by its height, relative size, and odd shape, the Flat Iron Building nonetheless quickly won the city's affection. Leading photographers, such as Alfred Stieglitz, produced enduring images that made the building a true icon of the new twentieth century. Offering visual punctuation to the south end of Madison Square, where Broadway and Fifth Avenue crossed, the building, officially the Fuller Building, was the first skyscraper erected with an all-steel frame. Here vigorous street life is depicted swirling at the structure's base. A full moon has been inserted as well as an airplane in faint outline, the latter, no doubt, intended to make the scene seem more fully progressive. The insertion, however, also served to amplify the building's apparent height. "It is 300 feet high," this card's caption reads, "and contains 120,000 square feet of floor space above ground and 13,240 square feet under the sidewalk."

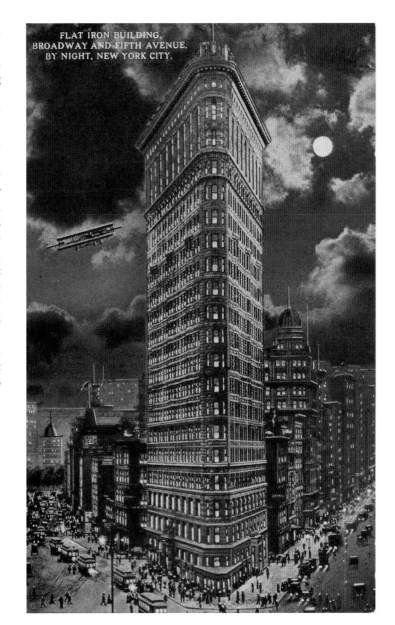

FLAT IRON BUILDING, BROADWAY AND FIFTH AVENUE, BY NIGHT, NEW YORK CITY.

NEW YORK CITY, NEW YORK. THE FLAT IRON BUILDING, CIRCA 1910.

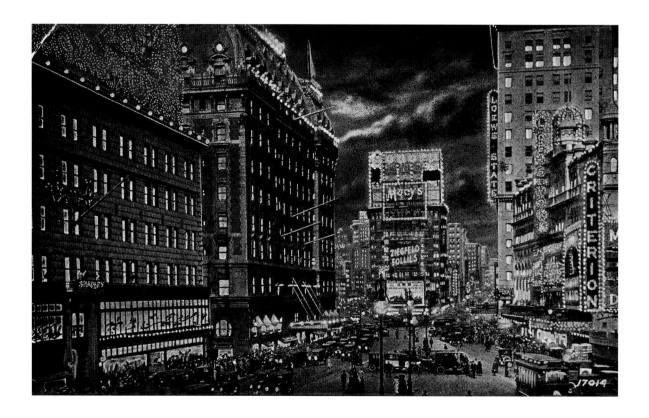

*B*right streetlights, as well as lit theater marquees, made Broadway glitter white while concentrations of immense electric advertising signs made "the Great White Way," especially at Times Square, colorful. Throughout the 1920s, incandescent lamps by the hundreds of thousands lit signboards high up on buildings, and spectacular they were as they outlined giant dancing toothbrushes and a mammoth chariot race, as they simulated fireworks, and as they contained every variety of blinking, pulsating light imaginable. Here was the symbolic center of New York City defined—appropriate to the center of American capitalism—by outdoor advertising's excesses. "Brilliantly lighted display windows and the numerous electric signs brighten up this thoroughfare at night," this card's caption reads in understatement. "Thus is the most fashionable hotel and theatre district, and in the evening it is crowded with playgoers and other pleasure seekers, who patronize the restaurants and cabarets."

NEW YORK CITY, NEW YORK. TIMES SQUARE, CIRCA 1925.

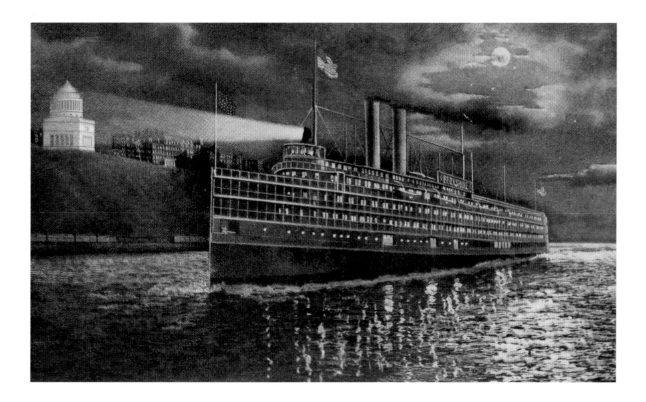

City landmarks, especially buildings unusual for size, configuration, or purpose, invited nighttime illumination through floodlighting and, accordingly, postcard depiction. Lit landmarks helped orient people in finding their way around cities at night. Landmarks figured prominently in the "mental maps" that residents and visitors alike formed in conceptualizing city space. Landmarks of some antiquity, or associated with some important past event or celebrated person, oriented in a temporal sense as well. This card's caption notes: "In leaving New York for a trip up the Hudson River on one of the evening steamers, the panorama of the towering skyline . . . [and] the busy river combine to impress upon the mind the awe-inspiring greatness of the metropolis of the new world. Grant's Tomb is passed . . . and the searchlight usually does not miss the opportunity to illuminate the imposing structure." Depicted was a monument not just to the hero of the Civil War and, of course, a former U.S. president but, as well, to the importance of New York City as his final resting place.

NEW YORK CITY, NEW YORK. THE HUDSON RIVER, CIRCA 1925.

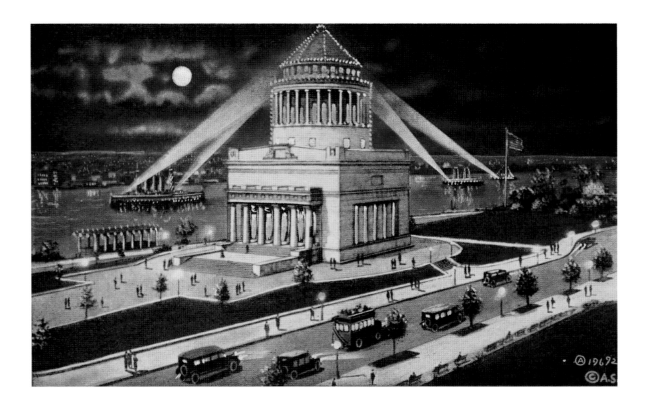

Most postcards were published as one of a series of cards: part of an array of images intended, when taken together, to capture pictorially a city's overall personality. To neglect key landmarks was to reduce potential sales. However, hitting upon the scenes that made the most profitable cards most often required some trial and error. Customers might be attracted to a postcard for aesthetic reasons, but to be a big seller a scene usually had to depict some truly important symbol of locality. Thus, postcard captions often emphasized superlatives, as if to remove all doubt as to a pictured site's import. Americans readily consumed talk of greatness or, at least, of bigness. They were impressed by size and cost. "Here, side by side, lie the remains of General U. S. Grant and his wife," this card's caption confides. "The tomb is a square 90 feet on each side and 72 feet in height, built of white granite with marble interior, and cost $600,000."

NEW YORK CITY, NEW YORK. GRANT'S TOMB, CIRCA 1925.

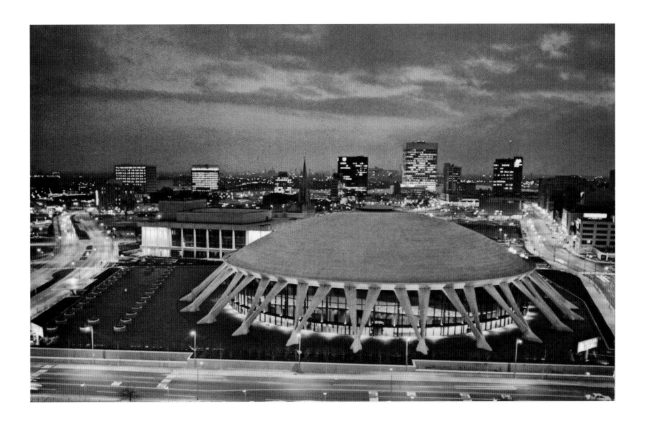

Urban redevelopment, through subsidy of "urban renewal" and other programs of the federal government after World War II, accelerated the rise of the auto-oriented city. In this view, wide thoroughfares, little reflecting the character of Norfolk's traditional street pattern, funnel traffic into and around a loose cluster of buildings: the ensemble of a new civic center. The city's skyline rises immediately behind. The domed convention hall is surrounded by an open void that is, in fact, the deck of a huge parking facility. Fully articulated accordingly is a new "object-in-space" formula through which city place-making late in the twentieth century accommodated automobile convenience. Night light outlines a scene where viewers are invited to insert themselves only as motorists. Little if anything offers encouragement to pedestrians.

NORFOLK, VIRGINIA. CONVENTION CENTER AND CULTURAL CENTER, CIRCA 1975.

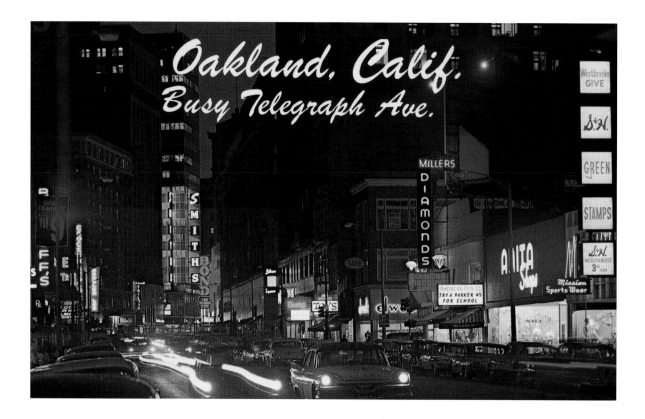

This postcard's caption announces: "Spectacular View at Nite [sic] of one of the busiest streets in the heart of the downtown business district in California's fourth largest city." Depicted is a traditional downtown street very much meant to appeal to pedestrians, but in keeping with the changing times, the photographer has chosen to instead emphasize the street as a traffic artery. Blurred headlights are used in extending to Oakland "big city" bragging rights. No romantic moon has been inserted to fill the darkened sky. Rather, the card's designer has inserted bold lettering: "Oakland, Calif. Busy Telegraph Ave." What is the publisher's purpose? Perhaps it is to emphasize that for Oakland there is, despite Gertrude Stein's condemnation, actually "a there there." Such labeling, of course, came to characterize postcard views of many cities after 1950, the modern functionality of bold captioning replacing the romanticism of retouched skies.

OAKLAND, CALIFORNIA. TELEGRAPH AVENUE, CIRCA 1960.

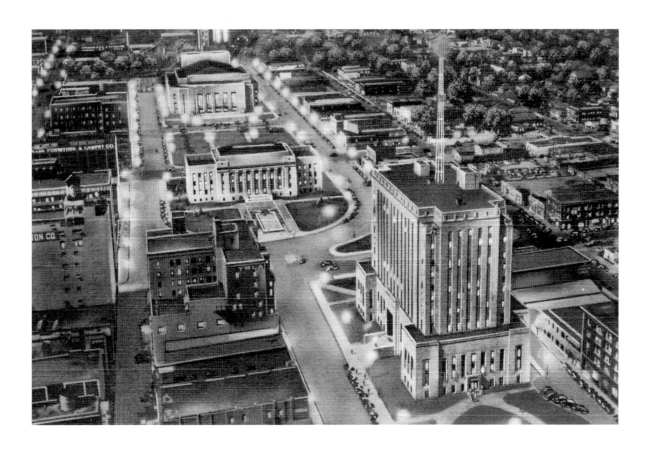

In the decades just prior to and after World War I, the "City Beautiful" movement promoted creation of extensive, parklike spaces to set off new civic architecture. That impulse, as well as an embrace of the automobile through widened and brightly lit thoroughfares, is certainly apparent here. This card's caption proudly proclaims: "Oklahoma City's Civic Center scintillates with its new unique mercury-vapor lighting system. It shines nightly in a blaze of glory undreamed of in the old railway right-of-ways. This feature represents the latest in scientific lighting and it is the largest initial set up of its kind in the United States." Obviously, everything was up-to-date in Oklahoma City. (Postcard courtesy Lake County [IL] Museum, Curt Teich Postcard Archives.)

OKLAHOMA CITY, OKLAHOMA. CIVIC CENTER, CIRCA 1937.

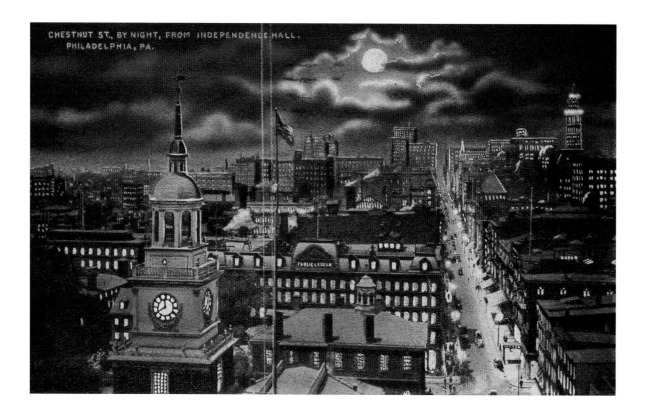

CHESTNUT ST. BY NIGHT, FROM INDEPENDENCE HALL.
PHILADELPHIA, PA.

PUBLIC LEDGER

*P*ostcards helped sustain stereotypic impressions of urban landscape, what some authors have called city "tableaux," a special kind of visual fix. The abstracting, focusing, and emphasizing of night light created visual displays against which city residents and visitors alike could measure a city's performance as a place of enterprise and even as a place of cul-ture. Photo retouching sustained, if it did not amplify, favorable cameolike impressions. Streets might be stripped of their power lines or automobiles might be inserted in place of wagons pulled by horses, to thus speak of anticipated, if not actual, modernity. Against such displays, the past could be reckoned. Society could turn back on itself to judge the direction and the extent of its progress. Shown is the tower of Independence Hall, the old Pennsylvania State House. Associated with this building are important political events of the nation's past, but here the landmark is seen in a surround of updated nighttime brightness, the past set fully in modern context.

PHILADELPHIA, PENNSYLVANIA. VIEW FROM INDEPENDENCE HALL, CIRCA 1920.

Philadelphia, Chicago, St. Louis, San Francisco, and New York City, among a host of other cities, competed for international attention through the sponsoring of lavish expositions or world's fairs. Every fair was built around one or more identifying architectural symbols that spoke to historical (or, alternatively, futuristic) themes. Philadelphia's 1926 fair featured a huge likeness of the Liberty Bell, set to glowing at night with thousands of electric incandescent lamps. The real bell was not only a city symbol but, as well, a symbol of a nation built around liberal ideals. At the city's 1876 Centennial Exposition, the giant Corlis steam engine momentarily captured the nation's attention, standing symbolic, as it did, of the nation's industrial success. It did so even though the United States was well into a new electrical age characterized more by electric turbines and motors. The electrically lit facsimile of the Liberty Bell, however, proved a feeble, easily forgotten symbol, the illuminated city at large offering much more powerful nighttime imagery.

PHILADELPHIA, PENNSYLVANIA. THE ELECTRIC LIBERTY BELL AT THE SESQUI-CENTENNIAL INTERNATIONAL EXPOSITION, 1926.

"*H*i nice people," this card's hand-written message reads. "Arrived safe and sound. Enjoyed the flight. No trouble. Weather is beautiful as usual. Love Irene." Notes written on scenic postcards usually communicated little more than mundane personal thoughts but always against a background of a pic-tured place. Even without conscious deliberation, sender and receiver alike were set to communicating about land-scape: "This is where I've been." "This is what you can see here." "You ought to see this place." Ways of looking at specific cities, and of looking at urban places gen-erally, built up over time as Americans sent and received city postcard views. Predispositions to seeing accrued, estab-lishing not just what needed to be seen but how it ought to be visualized when seen.

PHOENIX, ARIZONA. CENTRAL AVENUE, CIRCA 1955.

FIFTH AVENUE AT NIGHT, PITTSBURGH, PA.

*E*arly on, retouching daytime photos enabled postcard publishers to retain visual detail otherwise lost in actual nighttime photography. Dubbing also enabled publishers to add nonexistent detail in order to enhance a picture's strength. The actual streetlights in this view have been ignored by the photo retoucher. They stand as if unlit. Instead, sets of fictitious lamps have been inserted to imply full brightness in a street actually very dimly lit. Depicted, with this subterfuge, was a level of illumination appropriate to a major downtown street in a big city such as Pittsburgh. Here was a nighttime as proud Pittsburgh residents would have wished it to be. Here was a Pittsburgh that visitors would have wanted to remember and would have had others think they had seen.

PITTSBURGH, PENNSYLVANIA. FIFTH AVENUE, CIRCA 1905.

*H*ere is the home of the Pittsburgh Pirates. Ballparks lit at night amplified the visual spectacle of sport. Accordingly, night baseball was introduced in the Major Leagues to bolster sagging franchises in Cincinnati, Brooklyn, and Pittsburgh. At night "under the lights," baseball offered city residents a reprise from daytime obligations whether of the factory, office, sales floor, or home. In many ways did nighttime illumination invite relaxed spending of leisure time. The floodlit stadium was merely added to the list of other nighttime entertainment places, such as theater districts, amusement parks, and beach-oriented boardwalks and piers. (Postcard courtesy of Lake County [IL] Museum, Curt Teich Archives.)

PITTSBURGH, PENNSYLVANIA. FORBES FIELD, 1941.

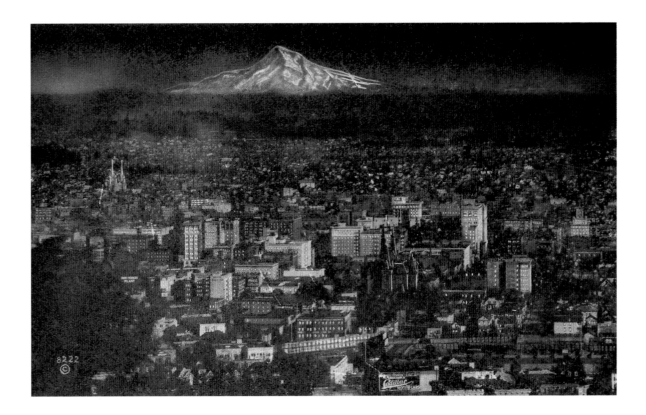

Work was begun in 1913 on the Columbia River Highway so that automobile tourists might be attracted since the new road accessed extraordinary natural scenery along the river's gorge east of the city. Urban modernity and unspoiled nature were advertised as coexisting in close proximity at Portland, an idea fully celebrated in this postcard view. Here Mt. Hood is seen to glisten in the moonlight, competing vigorously with the downtown's brightly lit skyline as a symbol of locality. Of course, two photographic prints have been combined, making Mt. Hood appear much larger (or much closer) than in reality.

PORTLAND, OREGON. VIEW EAST OVER DOWNTOWN, CIRCA 1920.

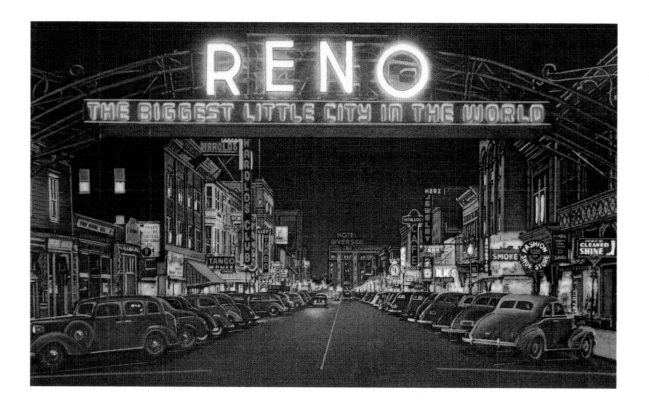

The eye is forcefully pulled into this view. A vista is framed by a sign arching overhead and is reinforced by peripheral lines of lit storefront receding toward the street's termination several blocks away. It is a unified scene. The picture's edges, of course, provide a containing frame to bound the viewer's gaze. Yet when something pictured within a view also serves to frame, the sense of containment is heightened. When enframement is in the middle ground, as here, a set of succeeding views is set up — a vista within a vista — that further hastens the eye forward into a doubly "windowed" world. In this view, a city's personality is made to reflect in a containment of bright night light. This postcard's caption describes Reno not only as "sparkling" but as "zestful." The card's caption and the sign shown herald Reno, then a city of only some thirty thousand people, as "The Biggest Little City in the World." (Postcard courtesy Lake County [IL] Museum, Curt Teich Postcard Archives.)

RENO, NEVADA. VIRGINIA STREET, 1941.

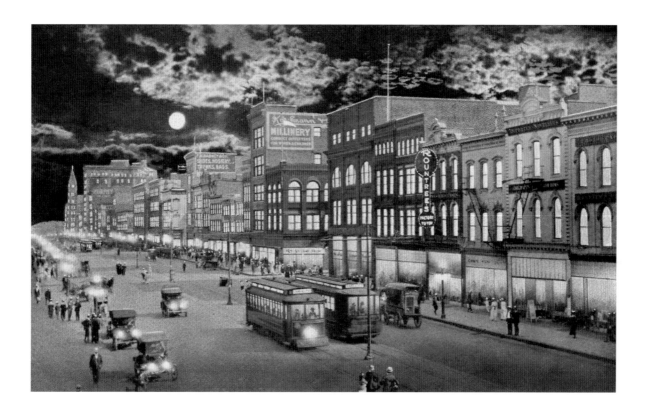

*E*xquisite for its vibrancy, this image is, nonetheless, the result of extensive doctoring by the printer. The sky is a separate photograph against which a street scene has been placed as a carefully cropped overlay. Light is made to shine in every window but with a subtlety rare in photomechanically printed cards.

Note the motormen and the passengers in the streetcars dubbed in to appear silhouetted in the windows. A stereotypic moon has been inserted into the night sky but is, in fact, correctly positioned to produce the backlit cloud effects pictured. This is an early Curt Teich (C. T. American Art) postcard printed for Louis

Kaufman and Sons of Baltimore, the latter firm modestly advertising itself on the card as "Publishers of Local Views." Curt Teich, Sr., emigrated from Germany to Chicago, bringing with him European printing techniques and an attention to detail that is apparent here.

RICHMOND, VIRGINIA. BROAD STREET, CIRCA 1915.

*U*nlike Europeans, Americans seldom demanded excellence in postcard art. They accepted readily the heavy-handedness of stereotypic photo retouching. American postcards were less expensive to manufacture and thus were more affordable, an invitation, in and of itself, to mass-marketing. In the United States, the postcard became a cheap form of "pop" art. Nonetheless, very high quality could be found on occasion. In this view, the photographer and the printer worked not just to produce a scene but to capture a feeling. There is something of the pictorialist stance in this image. Depicted is a special time, as well as a special place, defined by light subtly refracted through a light rain. Light is seen to shimmer, reflected in the wetness of sidewalk and street, and to dance in the glare of streetlights as well. Celebrated here is romantic dark shadow rather than awe-inspiring brightness. The depicted scene, however, did not preclude a mundane handwritten message: "We had a nice trip so far and just got through. Laughing because Clarence says the bed bugs are biting already. It is 1:30 right now, but no [sleep for me] till I get these postals out."

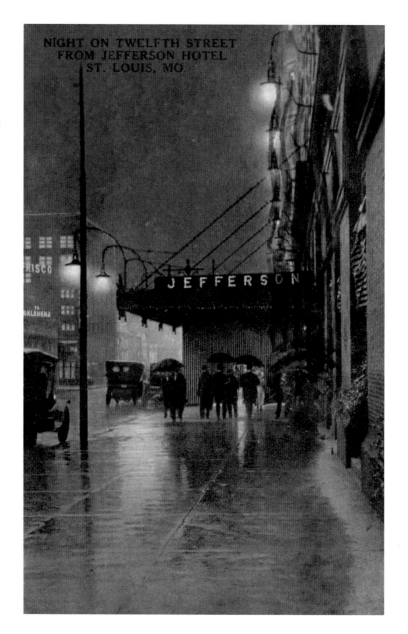

ST. LOUIS, MISSOURI. TWELFTH STREET, CIRCA 1920.

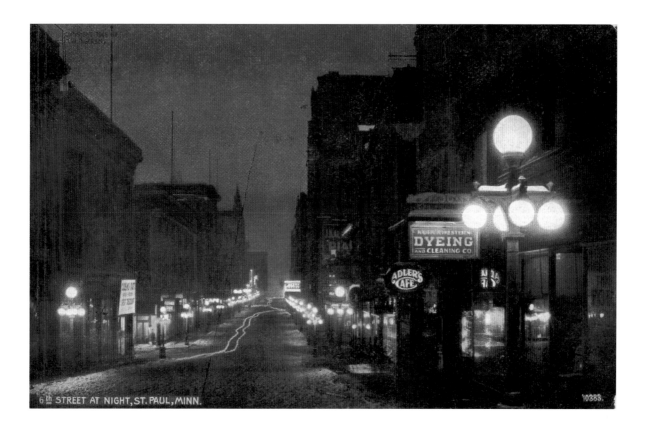

*H*ere is an early nighttime view based on an actual nighttime photograph. Lighting, variously articulated, communicated in the night as a sign or symbol system. As visual effect, it could transcend the immediate objectification of things to communicate at various other levels of symbolism. In the abstract, patterned light helped establish tension between partness and wholeness at the scale of the city, making it possible to conceptualize the whole by reference to its parts, and vice versa. In outlining the night as landscape, postcard views demonstrated how categories of meaningful place nested within. Depicted place also could be used to suggest connection over time. Notice in this view the twisting streaks of light at midstreet. Caught are the blurred lantern lights of a carriage making its way slowly along: a ghostlike trace of antiquated activity caught and woven into the scene's composition.

ST. PAUL, MINNESOTA. DOWNTOWN STREET, 1908.

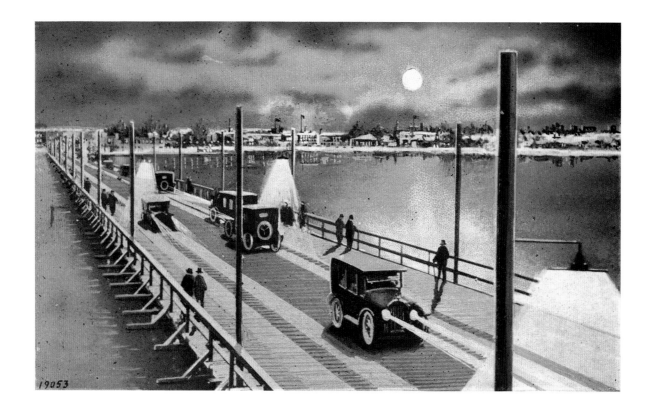

At night out along the city's munici-pal pier, pedestrians and motorists moved between regularly spaced pools of light. In the relative darkness of Tampa Bay, one could pause and look back at the brightly lit shore. The pier forms a diagonal across the picture's rectangular frame. Thus, the viewer's eye is at once attracted by the pier's trajectory land-ward. However, insertion of a bright moon, shown as reflected on the water beyond the pier, diverts attention toward a distant panorama. Additionally, a ten-sion has been set up between the hori-zonality of the shoreline and the verticality of the light poles. Here is photo composition well beyond the ordinary.

ST. PETERSBURG, FLORIDA. MUNICIPAL PIER, CIRCA 1920.

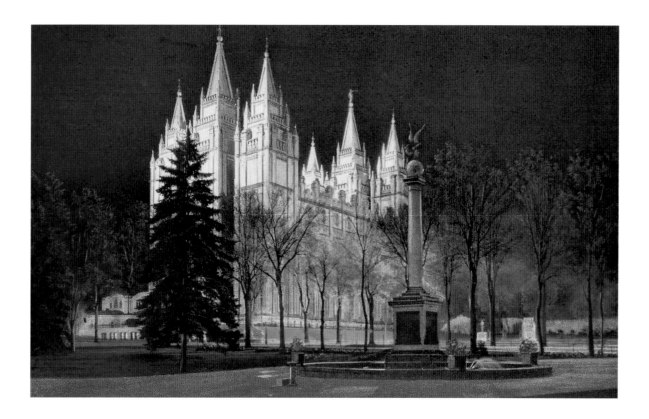

At night, light creates place, its articulation intended to cue place meaning. Places are social settings variously structured to invite categories of recurring behavior, with people fitting themselves into places according to need and aspiration. Some places loom very large in collective thinking. Here is Temple Square in Salt Lake City, the temple of the Church of Jesus Christ of Latter-day Saints floodlit in the night. The building elicits a strong "sense of place" among Mormons as a ritual place inviting narrow ranges of church-related behavior. So also does it serve as an important symbol for the host city as well as for the state of Utah. Place meaning involves elements of belief, attitude, and intentionality that linger on in people's minds and that attach to places, or to kinds of places, both through direct experiencing and indirect experiencing, as, for example, through the consumption of postcard art.

SALT LAKE CITY, UTAH. TEMPLE SQUARE, 1930.

Special streetlight luminaires, light festoons, and floodlit building facades were all used to amplify a sense of nighttime exotica in San Francisco's Chinatown. Here was an early example of "theming" whereby a special "sense of place" was actively promoted specifically for visitor consumption. During the day, Chinatown functioned as a work and residential area for much of San Francisco's Chinese-American community. At night, though, Chinatown became an entertainment zone, its special lighting not only advertising the same but providing much of the visual ambience that communicated to visitors a sense of cultural difference. Here was playful parody. Building facades were ornamented in ways suggestive of China and many signs were in Chinese, but it was also the exaggerated use of color in nighttime illumination that set a special mood so inviting to tourists. As well, night lighting made visitors feel safe, the darkness made sufficient to tease romantically but not to alienate. This postcard's caption reads: "Curved roofs, pagoda like temples, emblazoned with modern lighting effects, together with the mellow yellow of the oriental street lamps, intrigue the shopper and visitor on a night trip thru [sic] San Francisco's famous Chinatown, quaint and mystic." Symbolized was a safe departure from cultural norms that suggested, perhaps, more than it delivered. (Postcard courtesy Lake County [IL] Museum, Curt Teich Postcard Archives.)

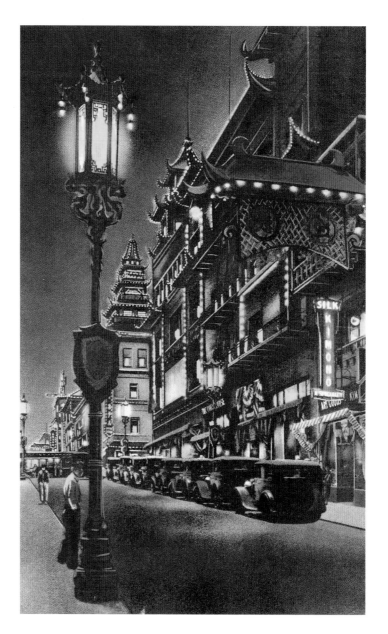

SAN FRANCISCO, CALIFORNIA. CHINATOWN, 1934.

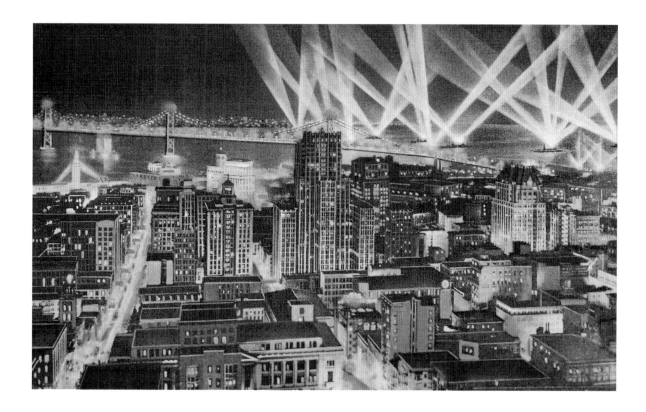

"*B*rilliant and dazzling are the Search- light displays on San Francisco Bay from the Battleships of the Pacific Fleet," this postcard's accompanying caption reads. "These radiant night shafts of light accentuate the lights on Market Street, the 'Path of Gold' and the East Bay Shore." Here was San Francisco at its dazzling nighttime best: radiant boule- vard, floodlit buildings, illuminated bridge to Oakland, and, of course, the searchlight antics of the U.S. Navy. Earlier in the century, such spectacles were deliberately planned as light festi- vals, but depicted here is the serendipity of an ordinary summer's night in the calm prelude before Pearl Harbor.

SAN FRANCISCO, CALIFORNIA. VIEW OVER DOWNTOWN, CIRCA 1940.

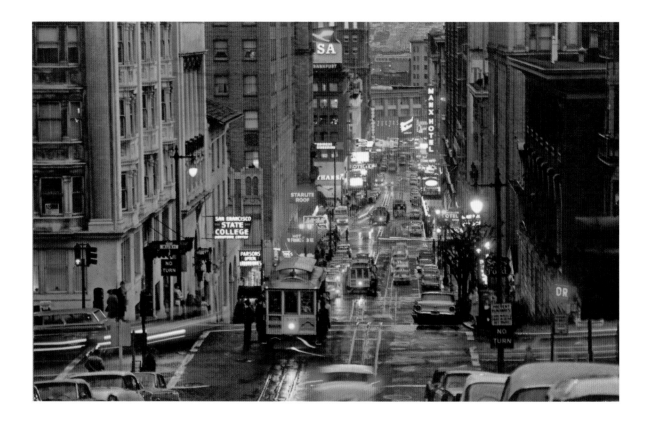

The lights of several of the city's famed cable cars blend into a night-time scene dominated by electric signs, streetlights, and the lights of automobiles. A photochromo, the picture tells a truth-ful story, with no dubbing apparent. Except for lit signs, storefronts are dark. Building facades do not glow from win-dows falsely portrayed as brightly lit. Wet streets, however, do reflect the headlights and taillights of cars with some blurring, the film and lens not quite fast enough to "stop action" completely. Powell Street, organized originally as a street for pedestrians, now accommodates the automobile with both moving cars in the street and cars parked at curbside. Viewed on a rainy night, the scene speaks not so much of an optimistically anticipated future so much as a struggle to hold on to past advantages now diminishing. Modern storefronts with new electric signs call out in simulation of new com-mercial strips located in San Francisco's burgeoning suburbs.

SAN FRANCISCO, CALIFORNIA. POWELL STREET, CIRCA 1970.

Postcards offered city boosters an opportunity to brag. For Seattle, the forty-two-story L. C. Smith Building was a key downtown landmark worthy of celebration. As this card's caption exhorted, it was "the highest and finest and most representative office building in the world outside of New York City." It weighed 32,630 tons and rested on 1,276 concrete pilings driven some fifty feet into the ground. At the top, adjoining the Observatory, was the Chinese Room with its bronzes and hand-carved teak woodwork. From both areas a "wonderful view" could be had of "snow-clad mountains, the sound, lakes, and green forests." "At night 42 giant searchlights flood the entire peak with a blaze of silver white light," the caption continued, "and surmounting all is the great electronically lighted ball, ten feet in diameter, serving as a beacon for all the ships entering the Seattle harbor."

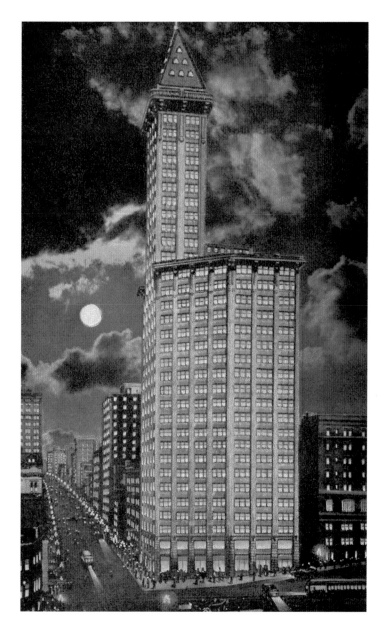

SEATTLE, WASHINGTON. L. C. SMITH BUILDING, CIRCA 1920.

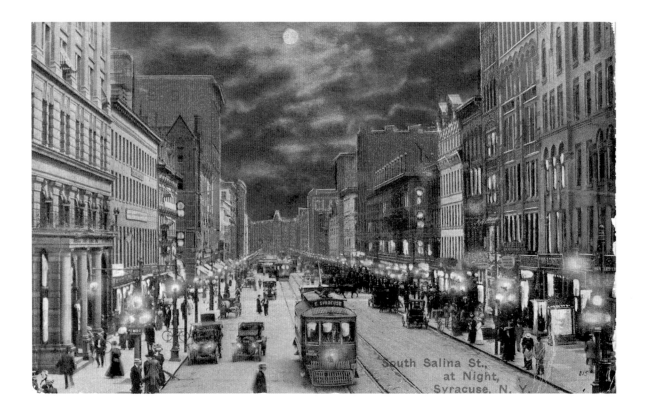

Here is a scene substantially altered through retouching. Power poles are gone, building facades are reconfigured, and, of course, a fictitious moon shines brightly above. "Had a good time last night celebrating the fair," the personal message reads. "How is Philadelphia? Write me. Leon." The automobile has arrived in Syracuse but electric signs apparently have not. Stores are open and pedestrians crowd the sidewalks, but the view is distanced by a telephoto lens making the scene appear rather impersonal. Perhaps anonymity was the essence of public space in big city downtowns? City streets were, many sociologists claimed, impersonal gathering places for strangers. In the city, individuals could get easily "lost" in the crowd. Postcard images, as "distanced" views, did little to refute such a claim.

SYRACUSE, NEW YORK. SALINA STREET, CIRCA 1910.

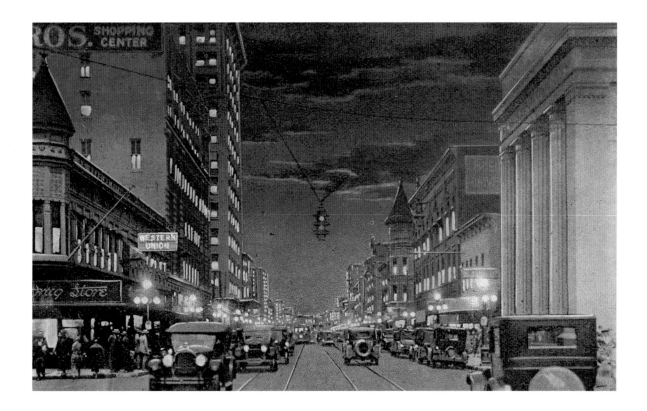

In the night, light announces, identifies, and sustains the functioning of places as distinctive settings for activity. As with the outlining of landscape, representation of place in the night involved standard pictorial strategies. In this view, the street edge is broken down into individual storefronts, the lights of which are dubbed in through retouching to thus differentiate one storefront from another. The scene further breaks down into sidewalks filled with pedestrians and a street filled with vehicles, additional place meaning fully implicit. At its most fundamental, a search for place meaning is a search for "refuge." On open sidewalks and streets, respectively, it involves identifying potential "points of pause": places where pedestrians might linger to gaze or to converse with one another or where motorists might stop to reorient themselves in driving or even to park.

TAMPA, FLORIDA. FRANKLIN STREET, CIRCA 1920.

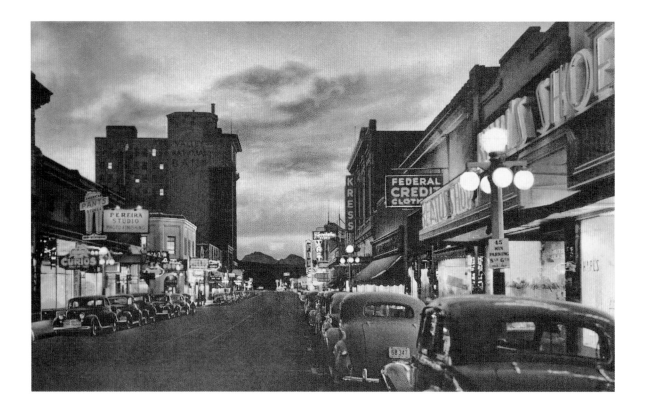

"As the Sun Goes Down and the Lights Come On," this postcard's brief caption begins in celebrating a special time of day. With color film, twilight was, perhaps, the ideal time to photograph night lights. Buildings remain outlined against the sky, with the sky itself colored in an array of hues. Still functioning here are the city's "white way" streetlights installed decades before. In the quasi-darkness new neon signs compete for the motorist's attention. So also do the "modernized" storefronts attract attention with their large fascia signs and enlarged display windows. (Postcard courtesy Lake County [IL] Museum, Curt Teich Postcard Archives.)

TUCSON, ARIZONA. CONGRESS STREET, 1933.

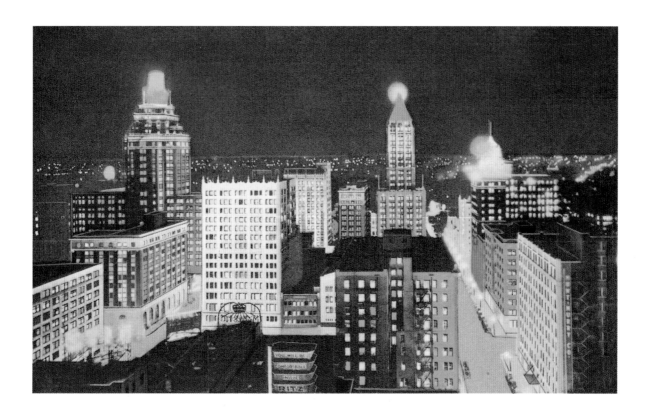

Riding the crest of a 1920 oil boom, Tulsa, like Houston, symbolized its new wealth through skyscraper development. Tulsa's skyline was impressive, being much more substantial than those of other cities of the same modest size. It was clearly a sight worth representing in postcard art. This card's personal message reads: "Tulsa . . . not quite 24 hours since we left Dayton. Seen lots of sights. Eva." Here was an invitation for Eva's friend to follow. (Postcard courtesy Lake County [IL] Museum, Curt Teich Postcard Archives.)

TULSA, OKLAHOMA. SKYLINE, 1938.

Through postcard art, the American city at night was made recognizable if not knowable. Most postcard views did sustain a kind of distancing, the nighttime city kept safely referential. On the one hand, postcards satisfied at the level of extreme generalization; viewers were made to contend not only with distanced seeing but with distanced knowing. On the other hand, postcards also could serve as an invitation to know places better, to someday get into scenes up close through personal experiencing. However it was that a nighttime view informed, excited, or satisfied, it enabled viewers to personally associate with the urban night. It enabled celebration of modern spectacle. Nighttime views of early-twentieth-century cities encouraged connection with the nation's emergent urban geography, and that geography, as depicted through visual formula, was, for the most part, made to seem not only inevitable but highly desirable. Here was offered visual iconography that validated dominant values in city-building, if not nation-building. (Postcard courtesy Lake County [IL] Museum, Curt Teich Postcard Archives.)

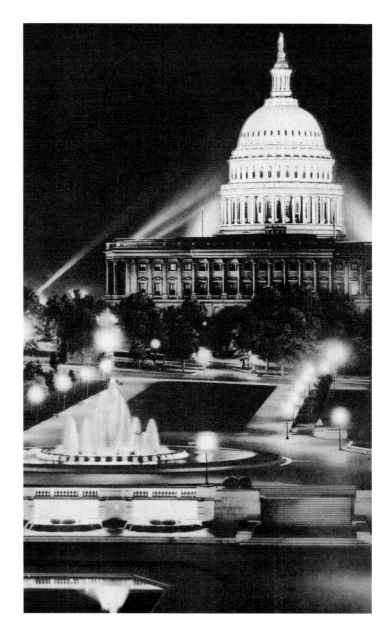

WASHINGTON, D.C. THE UNITED STATES CAPITOL, 1935.

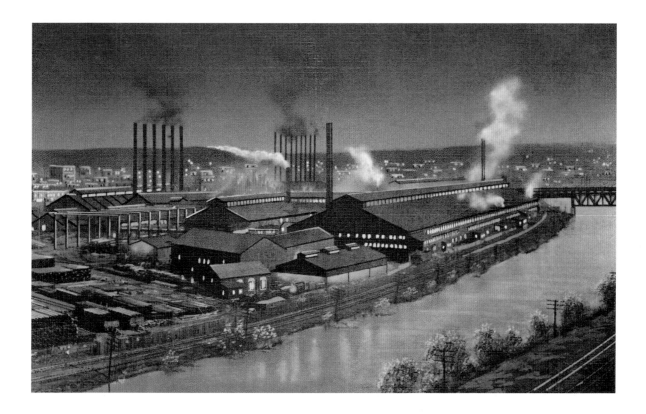

In emphasizing central business districts, postcard publishers did not totally ignore other urban areas, especially industrial sections that underpinned a city's economy. Railroads and the industrial zones that they served, especially along waterfronts, necessarily received some emphasis in blue-collar factory cities. Industrial areas tended to be dark at night, save where lights blazed in factory windows or where, as in Youngstown, Pittsburgh, and other steel centers, blast furnaces lit night skies with an orange glow. Of course, industrial work could be packaged as a tourist display, particularly in the form of the factory tour, but this was activity of the day. Industrial zones at night were inherently alienating to society's more refined classes and hardly were places of recreation for its working classes. Residents might take pride in a city's factories and visitors might marvel at them as well, but a nighttime memory of industry was, by and large, not a social imperative. Skyscrapers, the skylines that they formed, landmarks, and principal downtown streets dominated nighttime postcard depiction. (Postcard courtesy Lake County [IL] Museum, Curt Teich Postcard Archives.)

YOUNGSTOWN, OHIO. REPUBLIC STEEL CORPORATION, 1937.

AMERICANS BY THE TENS OF THOUSANDS still avidly collect postcards, some even specializing, it can be assumed, in images of the urban night. An industry of sorts, organized around collector's clubs, postcard shows, and Internet trading sites, among other venues, encourages as it facilitates such activity. In the United States, postcard aficionados are served by a moderately large, albeit still somewhat unsophisticated, literature comprised of bibliographies, histories, price guides, newsletters, and view books containing postcard reproductions. As a literature, it was somewhat difficult to access in the past, being targeted to a relatively narrow audience. Books on postcards even today do not readily appear on public library shelves or, for that matter, on the shelves of bookstores. Most postcard books are written by postcard enthusiasts for other enthusiasts and, accordingly, are published largely by small private presses with relatively limited market reach.

Recently, scholars and other writers have begun to seriously embrace American postcard art both as a topic of interest, and thus worthy of exploration in and of itself, and as a means of exploring other interests. For example, historic postcard views can disclose much about how life was once lived in America. Understanding how postcard images were created, and how cards were marketed and used, can disclose much about past American social values. However, since the postcard craze of the early twentieth century fizzled in the years after World War I, most Americans have remained indifferent to postcard imagery, so commonplace did it become. Indeed, with television, the renewed popularity of the cinema, and, most recently, the growing importance of the computer screen,

Americans have become overwhelmed by visual imagery, instilling in many a kind of visual torpor. We see things but we do not see them well, especially when it comes to "reading" visual representations. If historic postcard views have any value today, it is because they first of all offer a kind of awakening visual shock. They appear naive as a medium of visual expression and thus, being different, are a medium potentially instructive beyond the ordinary. In addition, they depict scenes at once familiar to viewers and yet also variously strange. In other words, they invite curiosity and attention.

Europeans have done somewhat better in valuing postcard art over the years. Being overall of higher quality, British, French, and German view cards, for instance, not only retained popularity longer but invited serious scholarship earlier. The European literature on postcards, some of it focused on North American postcard art, is quite sophisticated, with more of it being written for and marketed to a broad reading public. Nonetheless, for American readers, in the past at least, foreign postcard books also have tended to be difficult to discover and obtain. Today, however, we live in a computer age. What was elusive before is now much more accessible via the Internet. Nascent curiosity regarding postcard images, whether those images be historic or contemporary, domestic or foreign, can be readily pursued from the comfort of one's office or home using a personal computer.

For beginners and experienced postcard collectors alike, use of the Internet is most instructive. Type in the word "postcard" (through any reliable search engine) and up will come "Postcard Resources," a listing service funded by the Library Board of California. At this writing, the website lists worldwide 109 commercial dealers, forty-eight collector personal pages, thirty-eight trading lists,

and seventeen postcard clubs, associations, or forums. For a focused bibliographical search, tap into the Online Computer Library Center's "Worldwide Catalogue of Books" site. At this writing, the search for book titles containing the English word "postcards," the French "cartes postales," and the German "Ansichtskarten" (view card) produces 2,010, 657, and 233 citations, respectively. For a discussion of the Internet, see Jon Casimir, *Postcards from the Net* (St. Leonards, Australia: Allen and Unwin, 1996).

Outlined below are what I consider to be the references most useful in accessing and, indeed, appraising (or interpreting through close attention) postcard views. I emphasize books applicable to postcard collecting generally but also focus on books specifically concerned with American view cards, especially those of American cities. My intention is to provide a guide to finding and collecting postcard views that not only offers a general overview but reinforces this book's preoccupation with postcards that depict for early-twentieth-century American cities the urban night.

HISTORICAL OVERVIEWS

Where would one turn in reviewing the postcard's historical import? Two excellent books concerning American view cards are to be recommended. Hal Morgan and Andreas Brown in *Prairie Fires and Paper Moons: The American Photographic Postcard: 1900–1920* (Boston: David R. Godine, 1981) provide a succinct introduction to the American postcard's cultural and social implications. Jody Blake and Jeanette Lasansky in *Rural Delivery: Real Photos from Central Pennsylvania, 1905–1935* ([Lewisburg, PA]: Union County Historical Society, 1996) offer an assessment of how localities were pictured in postcard art. Taken together, these two books offer an introductory

short course on the positive uses of postcard imagery. Standing in stark contrast is Martin Parr's *Boring Postcards* (London: Phaidon Press, 2000). Presented, but unsupported by any written narrative, is an assortment of commonplace postcard images, a presentation seemingly calculated to demean postcards as vulgar and as lacking value. Contrary evidence pervades *Walker Evans: Gallery of Postcard Views*, edited by Jeff Rosenheim (New York: Eakins Press, 2000), and John Baeder's *Gas, Food and Lodging: A Postcard Odyssey Through the Great American Roadside* (New York: Abbeville Press, 1982). Evans and Baeder both demonstrate that the postal view card was— and is—not merely a thing but represents, as well, a way of seeing fundamental to the American experience. It is, after all, what the viewer brings to looking at postcards that makes them either interesting or boring.

Illustrated histories include Tom Phillips's *The Postcard Century: 2000 Cards and Their Messages* (London and New York: Thames and Hudson, 2000). Following a short historical sketch, emphasizing both British and American postcard art, two thousand sample views reproduced in color are arrayed according to their year of issue, from 1900 through 1997. Captions reproduce and discuss the messages originally written by the card senders, with each postcard having once been mailed. Other broad histories include Martin Willoughby's *A History of Postcards* (Secaucus, NJ: Welfleet Press, 1992); Frank Staff's *The Picture Postcard and Its Origin* (New York: Praeger, 1966); Michael Klamkin's *Picture Postcards* (New York: Dodd, Mead, 1974); and Richard Carline's *Pictures in the Post: The Story of the Picture Postcard and Its Place in the History of Popular Art* (London: Gordon Fraser Gallery, 1971; Philadelphia: Deltiologists of America, 1972). Postcard histories focused specifically on the United States include Dorothy B. Ryan's *Picture Postcards in the United States, 1893–1918* (New York: Clarkson N. Potter, 1982) and Tonie Holt and Valmai Holt's *Picture Postcards of the Golden Age* (Folson, PA: Deltiologists of America, 1971).

BIBLIOGRAPHIES

The most comprehensive bibliographies are European. Although focused on Europe, if not the country of publication, most contain sections on North American postcards as well as the postcard art of other world regions. For France it is Henry J. M. Levet's *Cartes Postales* (Paris: Table Ronde, 1993); Frederic Vitoux's *Cartes Postales* ([Paris]: Gallimand, 1993); and Annie Baudet and Francois Baudet's *Internationale de la Carte Postale* (Paris: S.N.R.A. Editeurs, 1978). For Germany it is Irma Bernard and Will Bernard's *Bildpostkartenkatalog: Deutschland, 1870–1945* (Hamburg: W. Bernard, 1980). For Austria it is Stefan Zweig's *Ansichtskarten von Frühen Reisen* (Wien: Edition Graphischer Zirkel, 2000). For a bibliography focused on the United States, see James L. Lowe's *Bibliography of Postcard Literature: A List of References to the Publishing and Collecting of Picture Post Cards* ([Folson, PA]: the author, 1969).

COLLECTORS' GUIDES

The collecting impulse is one gauged not only to assembling a postcard set somehow rationalized according to topic, type of card, publisher of issue, and so on, but to accumulating cards of value in anticipation of a future value increase. A card's rarity, and hence its monetary worth, is a function of the topic it treats, the nature of the card's production (including, for example, its method of manufacture, the size of its issue, and its publisher's market reach), the card's physical condition, and its contemporary

social relevancy, among other factors. Postcard price guides are numerous but become quickly outdated, requiring readers to adjust for price inflation.

For Great Britain, leading postcard collector's guides include Bob Allan and Lynn Hudson, *Postcards: A Guide for New Collectors* (York, UK: the authors, 1997); Geoffrey Gadden, *Collecting Picture Postcards* (Chichester, UK: Philimore and Co., 1996); Brian Lund, *Postcard Collecting: A Beginner's Guide* (Keyworth, UK: Reflections of a Bygone Age, 1985); Ron Mead, Joan Venman, and Dr. J. T. Whitney, *Picton's Priced Postcard Catalogue and Handbook* (London and New York: Longman, 1983); Anthony Byatt, *Collecting Picture Postcards: An Introduction* (Malvern, UK: Worchester Golden Age Postcard Books, 1982); and Frank Staff, *Picture Postcards and Travel: A Collector's Guide* (Guilford, UK: Lutterworth Press, 1979).

The list of American postcard guides is rather lengthy. More recent publications include J[oseph Lee] Mashburn, *The Postcard Price Guide: A Comprehensive Reference* (Enka, NC: Colonial House, 2001); Jane Wood, *A Collector's Guide to Post Cards* (Gas City, IN: L-W Promotions, 2000); Robert Ward, *Real Photo Postcards: Pre-1935 North American Cards* (Bellevue, WA: Antique Papers Guild, 1994); Diane Allmen, *The Official Identification and Price Guide to Postcards* (New York: House of Collectibles, distributed by Ballantine Books, 1991); Jack H. Smith, *Postcard Companion: The Collector's Reference* (Radnor, PA: Wallace-Homestead Book Co., 1989); Ray Cox, *How to Price and Sell Old Picture Postcards: A Guide to the Profitable Postcard Business* (Baltimore: Braemar Press, 1986); Valerie Monahan, *An American Postcard Collector's Guide* (Blanford, UK: Blanford Press, 1981); and Claude Pelieu, *Cartes Postales USA (Pris par le Vent)* (Toulouse, France: Ceditions, 1979).

In addition to collector's guides, a small serial literature is to be recommended. In Great Britain, it is the *Picture Postcard Monthly*, a sophisticated journal of high quality. In the United States, no such journal yet exists, the vacuum being honorably filled by various newsletters, prime among them, perhaps, *Barr's Postcard News* published in Lansing, Iowa. Many postcard clubs issue newsletters, for example, the bimonthly newsletter issued by the Metropolitan Collectors Club of New York City.

TOPICALLY ORIENTED VIEW BOOKS

Numerous books offer postcard views oriented to one or another subject matter, including such topics as bathing beauties, erotica, fantasy, hula dancers, lovers, ocean liners, quilts, railroads, streetcars, and wildflowers. Few view books offer much analysis or interpretation but can be useful in illustrating the nature of representative postcard art. Most view books offer readers (or viewers) little more than surrogate postcard images suggestive of what might or should be collected. For animal enthusiasts there are postcard books on alligators, cats, dinosaurs, dogs, owls, and penguins. For toy aficionados there are postcard books on Barbie dolls, Raggedy Ann and Andy dolls, and teddy bears. Holiday greeting cards originated in the United States as postcards. Thus, it should not be surprising to find many postcard view books with images of Christmas (especially of Santa Claus), Easter, Halloween, and St. Patrick's Day. Books with patriotic themes are numerous and tend to emphasize displays of the American flag. Also numerous are view books of military personnel and the battlefield sites of both World War I and II. Abraham Lincoln and, interestingly enough, Calvin Coolidge are the only presidents to enjoy separate books; the latter, of course, was reliant on postcard advertising during his political campaigns of the 1920s. Entertainment themes are

important, with portrayals of everyday comic situations (often enhanced through a clever play of words in captions), pictures of Walt Disney characters, pictures of athletes and athletic events (especially from Major League baseball), and pictures of television personalities and programs (*I Love Lucy* and *Star Trek*, for example). Elvis Presley enjoys separate book coverage, as might be expected. Roadside America, most often of the 1950s, is treated in books on automobiles (including one on hot rods), roadside diners, and Route 66. An array of postcard books concerns African-American and Jewish-American life.

LOCALITY-BASED VIEW BOOKS

Those interested in landscape and place will find little of immediate interest from most topically oriented postcard books. However, such is not the case with books dedicated to depicting given geographical areas. I emphasize here postcard books concerned with specific cities, limiting my survey, indeed, to those cities depicted above in nighttime views.

Several publishers offer city-oriented postcard books as a series. In the bicentennial year of 1976, Dover Publications, a publisher of photo books, released Haywood Cirker's *Thirty-Two Picture Postcards of Old New York* (New York: 1976). Subsequent Dover books included David Lower, *Thirty-Two Picture Postcards of Old Chicago: Ready-To-Mail* (New York: 1977); Robert F. Lowry's *Thirty-Two Picture Postcards of Old Philadelphia* (New York: 1977), *Thirty-Two Picture Postcards of Old San Francisco: Ready-To-Mail* (New York: 1977), and *Thirty-Two Picture Postcards of Old Washington: Ready-To-Mail* (New York: 1977); and Mary W. Davis, *Picture Postcards of Old New Orleans: Twenty-Four Ready-To-Mail Views* (New York: 1984).

The University of Tennessee Press has similarly treated Tennessee cities, including Charles Warren Crawford, *Memphis Memories: Thirty-Two Historic Postcards* (Knoxville: 1977); Allen Chesney, *Chattanooga Album: Thirty-Two Historic Postcards* (Knoxville: 1983); and James A. Hoobler, *Nashville Memories: Thirty-Two Historic Postcards* (Knoxville: 1983). Selected Minnesota cities have been treated by Voyageur Press. Relevant titles are Robert G. Murray's *Postcards of Early Minneapolis-St. Paul: Featuring Thirty-Two Ready-To-Mail Vintage Postcard Scenes* (Bloomington, MN: 1979), and Noemi Veyant's *Postcards from Early Duluth: Featuring Thirty-Two Ready-To-Mail Postcard Scenes* ([Bloomington, MN]: 1979).

Whereas locality-oriented view books of the 1970s and 1980s tended to offer postcard facsimiles that could be removed and actually mailed, more recent publications do not. The postcard is treated less as a collectible curiosity and more as a source of information. This is true of the very recent Arcadia Publishing Company postcard book list that includes the following titles: Richard Bak, *Detroit: A Postcard Album* (Charleston, SC: 1998); Scott Faragher, *Nashville in Vintage Postcards* (Charleston, SC: 1999), *New Orleans in Vintage Postcards* (Charleston, SC: 1999), and *Memphis in Vintage Postcards* (Charleston, SC: 2000); Joe Russell and Kate Shelley, *Baltimore in Vintage Postcards* (Charleston, SC: 1999); Elena Irish Zimmerman, *Chattanooga in Vintage Postcards* (Charleston, SC: 1998), and *Atlanta in Vintage Postcards* (Charleston, SC: 1999); Randall Gabrielson, *New York City's Financial District in Vintage Postcards* (Charleston, SC: 2000), and *Times Square and Forty-Second Street in Vintage Postcards* (Charleston, SC: 2000); and Patricia Kennedy, *Miami in Vintage Postcards* (Charleston, SC: 2000).

Other view books treat the following cities. Atlantic City: Judith Nina Katz and Chester Perkowski, *Atlantic*

City Remembered: Thirty-Two Postcards Made from Antique Photographs (Atlantic City: Chelsea Press, 1979). Boston: Geoff O'Neill, *Boston in Old Picture Postcards* (Roswell, GA: Intersound, 1991). Cleveland: Ralph Burnham Thompson, *Cleveland in Early Postcards* (Vestal, NY: Vestal Press, 1992). Fort Wayne: B. Decker and D. F. Mustard, *Fort Wayne Postcards: A Glimpse of the Past* (Fort Wayne: the authors, 1998). Houston: Joy Lent, *Houston's Heritage: Using Antique Postcards* (Houston: D. H. White, 1983). Kansas City: Mrs. Sam Ray and Doran L. Cart, *Post Cards from Old Kansas City* (Kansas City, MO: Historic Kansas City Foundation, 1987). Los Angeles: William A. Hartshorn, *A Book of Twenty-One Postcards* (San Francisco: Browntrout Publishers, 1996). Louisville: Gene Blasi, *Postcard Views of Louisville* (Louisville: the author, 1994), and Louis Cohen, *Postal History of Louisville, Kentucky* (Lake Oswego, OR: LaPosta Publications, 1987). New York City: Jack H. Smith, *Old New York in Picture Postcards, 1900–1945* (Lanham, MD: Vestal Press, 1999), Rod Kennedy, *Lost New York in Old Postcards* (Salt Lake City: G.M.S., 2001), and George J. Lankevich, *Postcards from Times Square: Sights and Sentiments from the Last Century* (Garden City, NY: Square One Publishers, 2001). Oklahoma City: Hal Ottaway, *The Vanished Splendor: Postcard Views of Early Oklahoma City* (Oklahoma City: Abalache Book Shop, 1982). Philadelphia: Philip Jamison, *Philadelphia in Picture Postcards: 1900–1930* (Vestal, NY: Vestal Press, 1990). Savannah: Howard Paul Blatner, *Savannah, Georgia, Images . . . Chromographic Postcards Including Inventories of Extant Published Images and Makers* (Savannah: the author, 1984). Youngstown: Larry Smith, *Steel Valley Postcards and Letters* (Youngstown: Pig Iron Press, 1992).

DATING OLD POSTCARDS

Many of the postcard guides listed above contain materials helpful in dating historical postcard views. Also useful is one guide specifically oriented in this regard: Barbara Andrews's *Directory of Post Cards, Artists, Publishers and Trademarks* (Irving, TX: Little Red Cottage Press, 1975). Articles outlining the histories of specific postcard publishers can be found in *Barr's Postcard News* and other newsletters. For the histories of two publishers emphasized in this book, see Jeff R. Burdick, *The Detroit Publishing Company: A Guide for Collectors* (Big Rapids, MI: the author, 1994), and Kim Keister, "Wish You Were Here: The Curt Teich Postcard Archives," *Historic Preservation*, Vol. 44 (March/April, 1992), pp. 4-7.

POSTCARD ARCHIVES

Researchers seeking to locate historical postcard images landscape- or place-related may want to approach libraries and history archives directly. There are few large public libraries that do not maintain at least small locality-oriented postcard collections. See Norman D. Stevens's *Postcards in the Library: Invaluable Visual Resources* (New York: Haworth Press, 1995). Local historical societies and historical museums also tend to maintain postcard collections, and many have sponsored the publishing of view books. One of the best is Anne Morse Lyell's *Wish You Were Here: Worcester Postcards, ca. 1905–1920* (Worcester, MA: Worcester Historical Museum, 1998). Postcard images, among other business records, have been preserved for several of the larger postcard publishers of the early-twentieth-century United States. For example, the images of the Detroit Publishing Company are to be found at the Henry Ford Museum in Dearborn, Michigan.

By far the most important archival collection is that of the Curt Teich Postcard Archives located at the Lake County (Illinois) Museum in suburban Chicago. At this writing, the collection contained some 360,000 catalogued postcard views produced by Curt Teich and Company between 1898 and 1978. The cards relate to some ten thousand localities across some ninety countries, the vast majority, of course, depicting places in the United States and Canada. Original production materials exist for some 110,000 cards manufactured between 1926 and 1960. These materials include photographic negatives and prints, layout sketches (including pencil and watercolor renderings), and supporting correspondence with customers. The Lake County Museum has become a major depository for American postcard art. Located there, for example, are five thousand postcards, largely of the American Midwest, produced by the V. O. Hammon Company of Chicago and Minneapolis. The museum also publishes annually the *Directory of Postcard Holdings in Public Museums, Archives and Libraries.* The 2001 edition listed eighty-seven public institutions in the United States and Canada that made postcard collections available for public research.

Agee, James. [Introductory Essay] in Helen Levitt, *A Way of Seeing* (New York: Horizon Press, 1981).

Appleton, Jay. *The Symbolism of Habitat: An Interpretation of Landscape in the Arts* (Seattle: University of Washington Press, 1990).

Benjamin, Walter. *Charles Baudelaire: A Lyric Poet in the Era of High Capitalism*, translated by Harry Zohn (London: NLB, 1973).

Bloomer, Carolyn M. *Principles of Visual Perception* (New York: Van Nostrand Reinhold, 1976).

Borchert, James. "Analysis of Historical Photographs: A Method and a Case Study." *Studies in Visual Communication*, Vol. 7 (1981), pp. 30–63.

Boyer, M. Christine. *The City of Collective Memory: Its Historical Imagery and Architectural Entertainments* (Cambridge, MA: MIT Press, 1998).

Broadwell, W. H. "Night Photography." *American Annual of Photography*, Vol. 23 (1909), pp. 68–71.

Bryson, Norman. "The Gaze in the Expanded Field," in Hal Foster (ed.), *Vision and Visuality* (Seattle: Bay Press, 1988).

Bryson, Norman, Michael Ann Holly, and Keith Moxey (eds.). *Visual Culture: Images and Cultural Interpretation* (Hanover, NH: Wesleyan University Press; published by University Press of New England, 1994).

Burnett, Ron. *Cultures of Vision: Images, Media, and the Imaginary* (Bloomington, IN: Indiana University Press, 1995).

Carline, Richard. *Pictures in the Post: The Story of the Picture Postcard and Its Place in the History of Popular Art* (London: Gordon Fraser Gallery, 1971; Philadelphia: Deltiologists of America, 1972).

Carrington, James B. "II—Night Photography." *Scribner's Magazine*, Vol. 22 (November 1897), pp 1, 626–28.

Conrad, Peter. *The Art of the City: Views and Versions of New York* (New York: Oxford University Press, 1984).

Corkett, Frederic T. "The Production and Collection of the Pictorial Postcard." *Journal of the Society of Arts,* Vol. 54 (April 27, 1906), pp. 622–33.

Crary, Jonathon. *Techniques of the Observer: On Vision and Modernity in the Nineteenth Century* (Cambridge, MA: MIT Press, 1990).

Cullen, Gordon. *The Concise Townscape* (New York: Van Nostrand Reinhold, 1961).

Curran, Raymond T. *Architecture and the Urban Experience* (New York: Van Nostrand Reinhold, 1983).

Davis, Timothy. "Beyond the Sacred and the Profane: Cultural Landscape Photography in America, 1930–1990," in Wayne Franklin and Michael Steiner (eds.), *Mapping American Culture* (Iowa City, IA: University of Iowa Press, 1992), pp. 191–230.

Dotterer, Steven, and Galen Cranz. "The Picture Postcard: Its Development and Role in American Urbanization." *Journal of American Culture,* Vol. 5 (1982), pp. 44–50.

Dreiser, Theodore. *A Hoosier Holiday* (New York: John Lane, 1916).

Earle, Edward W. (ed.). *Points of View: The Stereograph in America, A Cultural History* (New York: Visual Studies Workshop Press, 1979).

Evans, Walker. "Main Street Looking North from Courthouse Square." *Fortune,* Vol. 29 (May 1948), pp 102–6.

Green, Jonathon. "Introduction: Alfred Stieglitz and Pictorial Photography," in Jonathon Green (ed.), *Camera Work: A Critical Anthology* (New York: Aperture, 1973), pp. 9–23.

Guimond, James. *American Photography and the American Dream* (Chapel Hill, NC: University of North Carolina Press, 1991).

Hales, Peter B. *Silver Cities: The Photography of American Urbanization, 1839–1915* (Philadelphia: Temple University Press, 1984).

———. *William Henry Jackson and the Transformation of the American Landscape* (Philadelphia: Temple University Press, 1988).

Harris, Neil. "Urban Tourism and the Commercial City," in William R. Taylor (ed.), *Inventing Times Square: Commerce and Culture at the Crossroads of the World* (New York: Russell Sage Foundation, 1991), pp. 66–82.

H[artmann], S[adakicki]. "On the Possibility of New Laws of Composition." *Camera Work,* Vol. 30 (April 1910); reprinted in Jonathon Green (ed.), *Camera Work: A Critical Anthology* (New York: Aperture, 1973), p. 200.

Hunter, Jefferson. *Image and Word: The Interpretation of Twentieth-Century Photographs and Texts* (Cambridge, MA: Harvard University Press, 1987).

Hurley, F. Jack. *Portrait of a Decade: Roy Stryker and the Development of Photography in the Thirties* (Baton Rouge: Louisiana State University Press, 1972).

Isenberg, Alison E. "Downtown Democracy: Rebuilding Main Street Ideals in the Twentieth Century American City," unpublished Ph.D. dissertation, University of Pennsylvania, 1995.

Jakle, John A. *The Visual Elements of Landscape* (Amherst, MA: University of Massachusetts Press, 1987).

———. *City Lights: Illuminating the American Night* (Baltimore: Johns Hopkins University Press, 2001).

Jenks, Chris. "Watching Your Step: The History and Practice of the Flaneur," in Chris Jenks (ed.), *Visual Culture* (London: Routledge, 1995), pp. 142–60.

Jussim, Estelle. *The Eternal Moment: Essays on the Photographic Image* (New York: Aperture, 1989).

Jussim, Estelle, and Elizabeth Lindquist-Cock. *Landscape as Photograph* (New Haven, CT: Yale University Press, 1985).

Keister, Kim. "Wish You Were Here: The Curt Teich Postcard Archives." *Historic Preservation,* Vol. 44 (March-April 1992), pp. 4–7, 54–61.

Klamkin, Michael. *Picture Postcards* (New York: Dodd, Mead, 1974).

Kouwenhoven, John A. *Half a Truth Is Better Than None: Some Unsystematic Conjectures about Art, Disorder and American Experience* (Chicago: University of Chicago Press, 1982).

Lappard, Richard. *Art and the Committed Eye: The Cultural Functions of Imagery* (Boulder, CO: Westview Press, 1996).

Maddox, Jerald C. (ed.). *Walker Evans: Photography for the Farm Security Administration, 1935–1938* (New York: DeCapo, 1975).

Marvin, Carolyn. *When Old Technologies Were New: Thinking about Electric Communication in the Late Nineteenth Century* (New York: Oxford University Press, 1988).

Melbin, Murray. *Night as Frontier: Colonizing the World After Dark* (New York: The Free Press, 1987).

Miller, George, and Dorothy Miller. *Picture Postcards in the United States, 1893–1918* (New York: Clarkson N. Potter, 1976).

Morgan, Hal, and Andreas Brown. *Prairie Fires and Paper Moons: The American Photographic Postcard, 1900–1920* (Boston: David R. Godine, 1981).

Mullander, Jos. F., and Sidney Sprout. "Night Photography by Electric Light." *Journal of Electricity,* Vol. 1 (October 1895), pp. 84–85.

Nadeau, Louis. *Encyclopedia of Printing, Photographic and Photomechanical Processes: A Comprehensive Reference to Reproduction Technologies,* 2 vols. (Fredericton, New Brunswick: 1989–1990).

Naef, Weston J., and James N. Wood. *Era of Exploration: The Rise of Landscape Photography in the American West, 1860–1885* (Boston: New York Graphic Society, 1975).

"Night Photography," in *The Focal Encyclopedia of Photography* (London: Focal Press, 1957), pp. 770–73, 840.

Nye, David E. "Social Class and the Electrical Sublime, 1880–1915," in Rob Kroes (ed.), *High Brow Meets Low Brow: American Culture as an Intellectual Concern* (Amsterdam: Free University Press, 1988), pp. 1–20.

———. *Electrifying America: Social Meaning of a New Technology, 1880–1940* (Cambridge, MA: MIT Press, 1990).

———. *American Technological Sublime* (Cambridge, MA: MIT Press, 1996).

Orvell, Miles. *The Real Thing: Imitation and Authenticity in American Culture, 1880–1940* (Chapel Hill, NC: University of North Carolina Press, 1989).

Palka, Eugene J. "Coming to Grips with the Concept of Landscape." *Landscape Journal,* Vol. 14 (Spring 1995), pp. 63–73.

"Photolithography," in *The Focal Encyclopedia of Photography* (London: Focal Press, 1957), pp. 840–47.

"The Picture Post-Card." *Living Age,* Vol. 22 (July 30, 1904), pp. 310–14.

Platt, Harold L. *The Electric City: Energy and the Growth of the Chicago Area, 1880–1930* (Chicago: University of Chicago Press, 1991).

Prak, Neils L. *The Visual Perception of the Built Environment* (Delft, Netherlands: Delft University Press, 1977).

Riis, Jacob A. *How the Other Half Lives: Studies Among the Tenements of New York* (New York: Charles Scribner's Sons, 1901).

Ripley, John W. "The Art of Postcard Fakery." *Kansas Historical Quarterly,* Vol. 33 (Summer 1972), pp. 129–31.

Rota, Italo (ed.). *Not Only Buildings: New York,* translated by Chris Miller (New York: teNeues Publishing Co., 2000).

Ryan, Dorothy B. *Picture Postcards in the United States, 1893–1918* (New York: Clarkson N. Potter, 1982).

Schein, R. H. "Representing Urban America: Nineteenth-Century Views of Landscape, Space and Power." *Environment and Planning D: Society and Space,* Vol. 11 (1993), pp. 7–21.

Schultz, John, and Barbara Schultz. *Picture Research: A Practical Guide* (New York: Van Nostrand Reinhold, 1991).

Schwartz, Joan M. "'Geography Lesson': Photographs and the Construction of Imaginative Geographies." *Journal of Historical Geography,* Vol. 22 (1996), pp. 16–45.

Smith, Jonathan. "The Lie That Blinds: Destabilizing the Text of Landscape," in James Duncan and David Ley (eds.), *Place/Culture/Representation* (London: Routledge, 1993), pp. 78–92.

Smith, Peter. *The Syntax of Cities* (London: Hutchinson, 1977).

Staff, Frank. *The Picture Postcard and Its Origins* (New York: Praeger, 1966).

Steel, Richard. "The Pernicious Picture Post Card." *Atlantic Monthly,* Vol. 98 (August 1906), p. 288.

Stieglitz, Alfred. "Pictorial Photography." *Scribner's Magazine,* Vol. 26 (November 1899), pp. 528–37.

Stott, William. *Documentary Expression and Thirties America* (New York: Oxford University Press, 1973).

Szarkowski, John. *The Photographer's Eye* (Boston: New York Graphic Society, 1966), p. 4.

Taft, Robert. *Photography and the American Scene* (New York: Dover, 1964).

Tagg, John. *The Burden of Representation: Essays on Photographies and Histories* (Amherst, MA: University of Massachusetts Press, 1988).

———. "The Discontinuous City: Picturing and the Discursive Field," in Norman Bryson, Michael Ann Holly, and Keith Moxey (eds.), *Visual Culture: Images and Cultural Interpretation* (Hanover, NH: Wesleyan University Press; published by University Press of New England, 1994), pp. 83–103.

Taylor, Joshua C. *America as Art* (New York: Harper and Row, 1976).

Trachtenberg, Alan. *Reading American Photographs: Images as History, Mathew Brady to Walker Evans (*New York: Hill and Wang, 1989).

Urry, John. *The Tourist Gaze: Leisure and Travel in Contemporary Societies* (London: Sage, 1990).

Venturi, Robert, Denise Scott Brown, and Steven Izenhour. *Learning from Las Vegas: The Forgotten Symbolism of Architectural Form* (Cambridge, MA: MIT Press, 1972).

Ward, Robert. *Investment Guide to North American Real Photo Postcards* (Bellevue, WA: Antique Papers Guild, 1993).

Welling, William. *Collector's Guide to Nineteenth-Century Photographs* (New York: Collier Books, 1976).

Weston, Edward. "Seeing Photographically," in Nathan Lyons (ed.), *Photographers on Photography (*Englewood Cliffs, NJ: Prentice-Hall, 1966), pp. 154–63.

Wohl, R. Richard, and Anselm L. Strauss. "Symbolic Representation and the Urban Milieu." *American Journal of Sociology,* Vol. 63 (1958), pp. 523–32.